D1410936

Annabel Williams
weddings

RotoVision

A RotoVision Book
Published and Distributed by RotoVision SA
Rue Du Bugnon 7
1299 Crans-Près-Céligny
Switzerland

RotoVision SA, Sales & Production Office
Sheridan House, 112/116A Western Road
Hove, East Sussex BN3 1DD, UK

Tel: +44 (0) 1273 72 72 68
Fax: +44 (0) 1273 72 72 69
E-mail: sales@rotovision.com
Website: www.rotovision.com

Copyright © RotoVision SA 2001

All rights reserved. No part of this publication may be reproduced,
stored in a retrieval system or transmitted in any form or by any
means, electronic, mechanical, photocopying, recording or
otherwise, without permission of the copyright holder.

The photographs used in this book are copyrighted
or otherwise protected by legislation and cannot be reproduced
without the permission of the holder of the rights.

10 9 8 7 6 5 4 3 2 1

ISBN 2-88046-429-3

Book design by Kate Stephens

Production and separations in Singapore
by ProVision Pte. Ltd
Tel: +65 334 7720
Fax: +65 334 7721

Annabel Williams
weddings

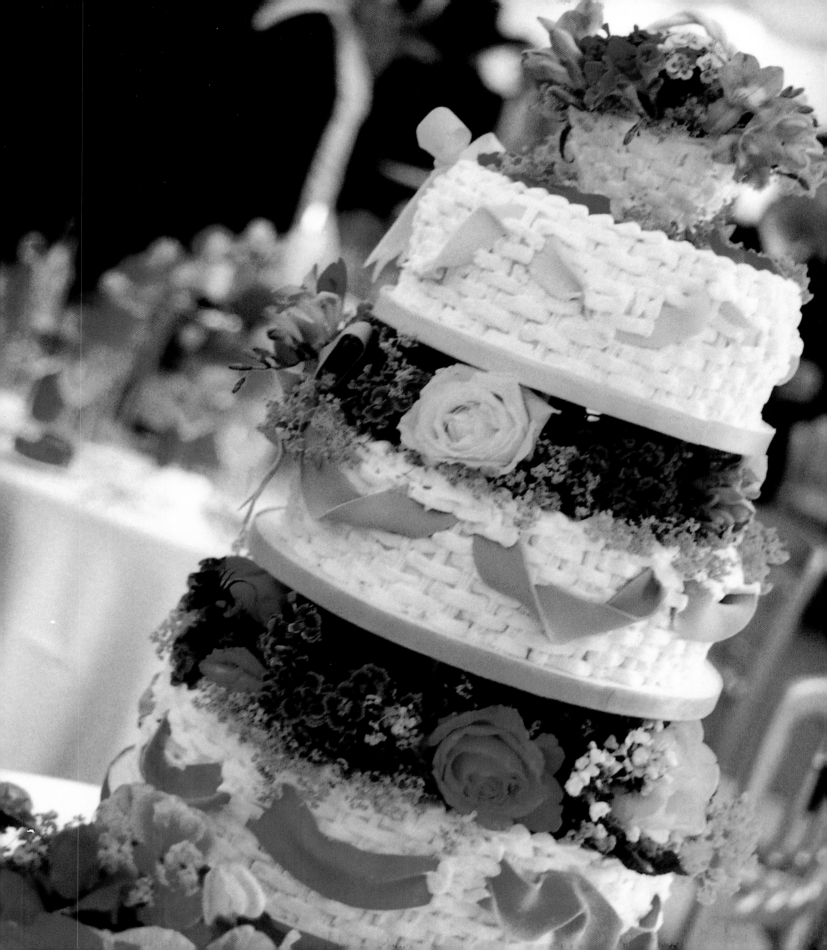

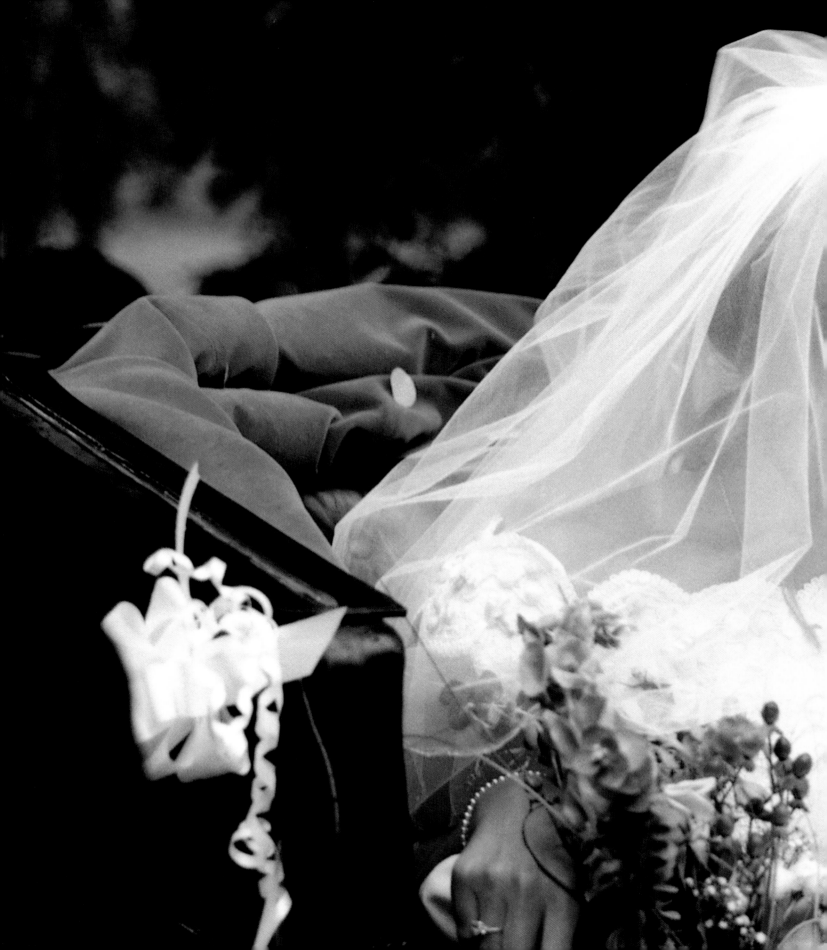

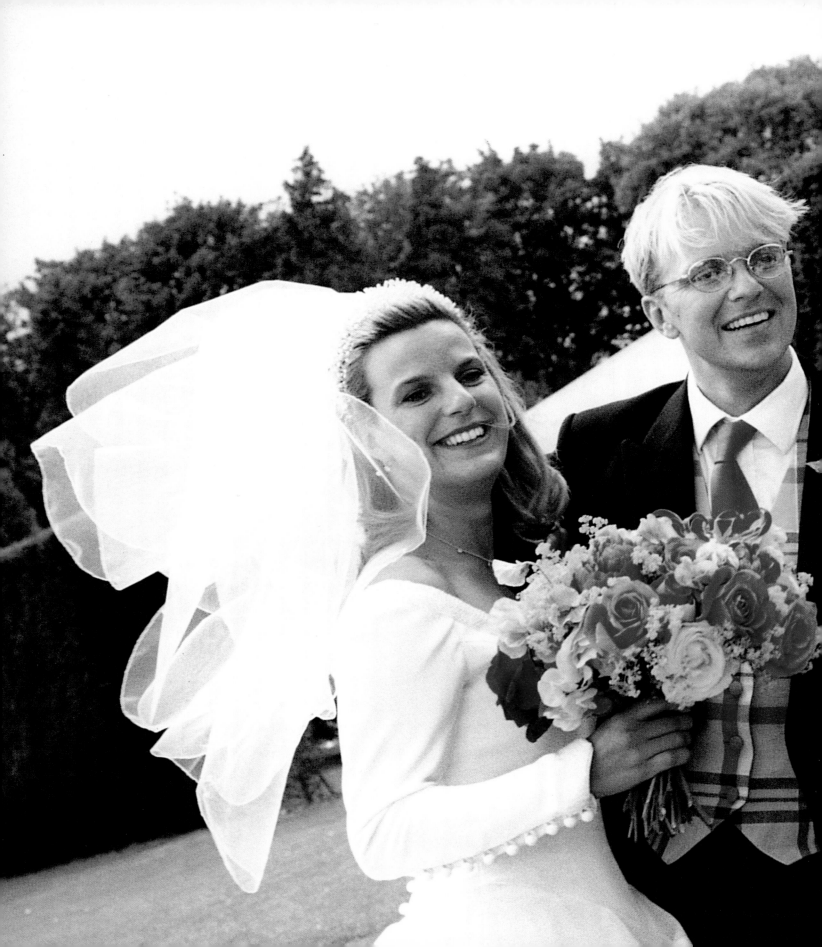

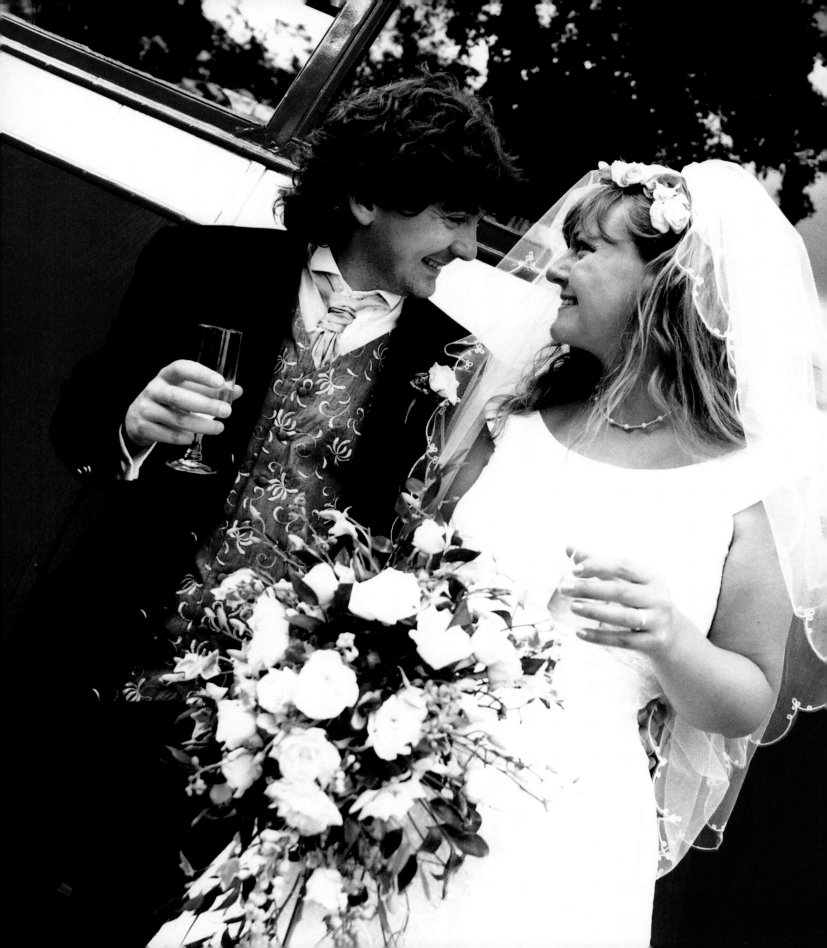

1 **contemporary wedding photography** **16**

2 **planning and preparing** **38**

3 **make-up and styling** **58**

4 **a real-life wedding** **68**

5 **location and lighting** **92**

6 **editing an album** **116**

7 **marketing for wedding photography** **126**

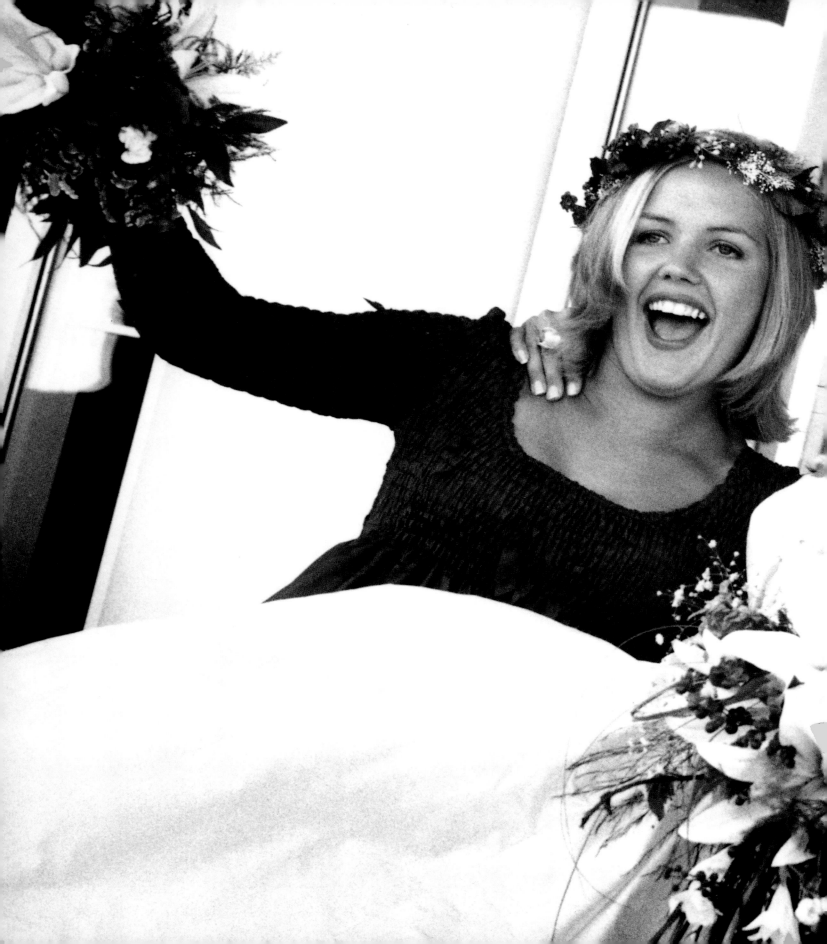

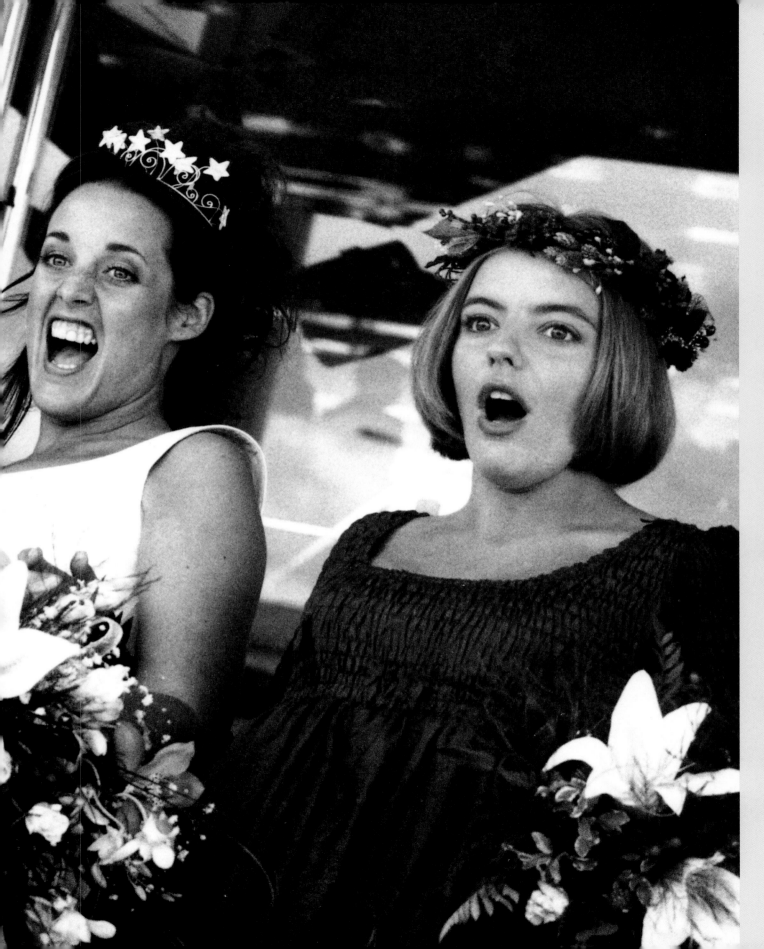

The images below are a more contemporary version of the 'church door' shot, and demonstrate how traditional and contemporary images can work successfully together.

Canon EOS 5, 75–300mm lens, Fujifilm Neopan 1600. Exposure 1/250sec at f/5.6

The traditional shot opposite of the couple in the church doorway is still very popular, and usually expected by both the couple and their parents.

Mamiya 645, zoom lens, Fujifilm NHG 800. Exposure 1/250sec at f/5.6

The wedding day is a landmark occasion in a person's life. This means that you have a responsibility to treat every wedding that you photograph as if it were the most important event of the year because, to the bride and groom, that's exactly what it is. They may have spent months or even years preparing for this moment, and it's up to you to complement their big occasion.

Today's wedding pictures should be a complete record of the event, and should have the feel of a storybook, rather than the appearance of something that has been stage-managed. Every picture taken on the day should, if possible, have a relaxed, natural and spontaneous feel about it, because today's clients are no longer prepared to pose statue-like for pictures. The main requirement for the modern couple is for a fun and honest record of the day as it really was, and the old principle of setting everything up for the benefit of the camera is now largely outdated. Be aware, however, that even for a photographer working in the contemporary style it is still important to include some of the more traditional images as many people still expect this, and the ratio of traditional and candid images is usually dictated through an assessment of the client's individual needs. Check carefully beforehand to make sure that you achieve the right mix of both in the portfolio that you ultimately deliver.

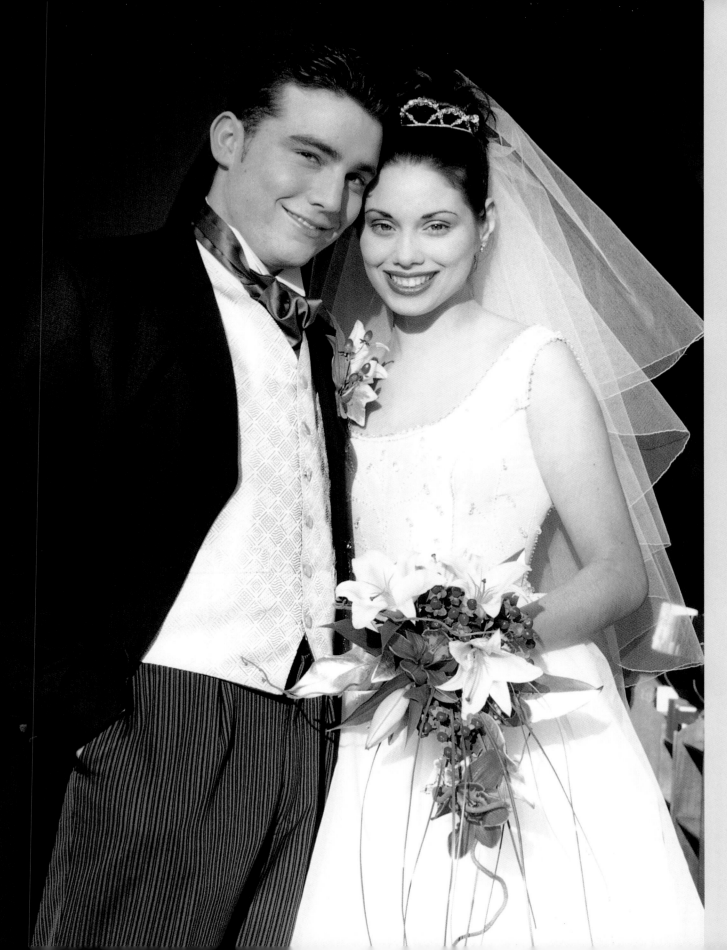

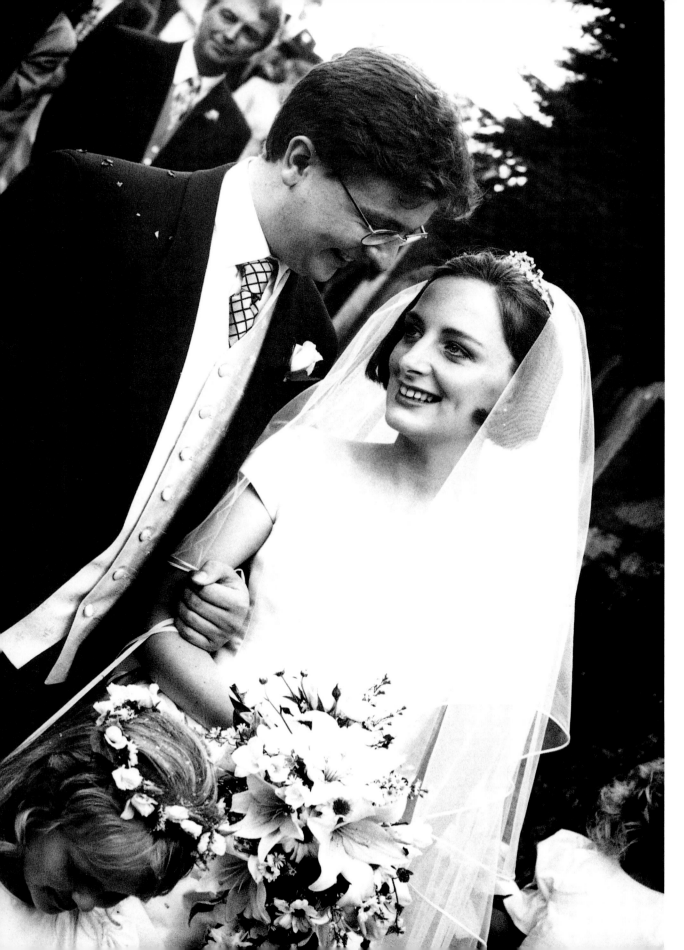

Formal pictures are a thing of the past – today's brides want to capture the fun and spontaneity of the day.

In years gone by the wedding photographer's job was to make a record of everyone in their finery and the requirement was often for pictures that appeared very set and formal. Today's lifestyle, however, is a far cry from the Victorian era during which this tradition started, but it has taken a long time for wedding photography to actually evolve to where it is now.

For many brides their perception of a wedding photographer is of someone who will take them away from their friends and family for hours to set up pictures that they don't really want anyway. Those who can challenge this way of doing things, and who can capture the spirit of the day through their pictures while interfering as little as possible, are the ones who find themselves in the most demand these days.

Wedding etiquette has changed dramatically over the years. Very rarely is a wedding a grand, formal affair – nowadays it is more of a celebration and a party. Contemporary wedding photography is about capturing the feeling and emotion of the day. People want to enjoy their day with as little interruption and stage management as possible. The pictures need to be realistic and the couple need to feel comfortable while they are being photographed. Gone are the days of holding static poses against the church doors: today's couples want their pictures to be natural, relaxed and spontaneous.

Your job is to get the best out of people, and if you can strike up a friendship with the couple you become a seamless part of their wedding, and people can relax and be themselves resulting in natural and spontaneous images.

Shooting candid pictures is about understanding people. It is not sufficient just to take snapshots: your work may feature a relaxed style, but it will still have to be of a high standard and composed beautifully if the pictures you produce are to look professional. The best results are achieved if you spend the necessary time developing a relationship with your clients before the wedding, so that you become their friend on the big day, and not an enemy who is hounding them through your camera. Your job is to get the best out of people, and if you can strike up a friendship with the couple you become a seamless part of their wedding, and people can relax and be themselves, resulting in natural and spontaneous images. If people feel tense and nervous, it will be very difficult to get them to do what you want.

You have to master the art of getting co-operation from your subjects – moving them into a shaded area, for example, so that the light is less harsh – without making it look as if you are controlling their every move. The only way this can be done is if you can win their trust, and the best way that you can do this is to cause as little interruption throughout the day as possible. When the client understands that you work quickly and efficiently, and yet still are capable of getting great results, you will find that they are happy to give you the freedom to do it your way.

These are not the kind of moments that occur naturally, but if the photographer can win the trust of the bride and groom then they will enjoy playing their part in photographs such as this, and will see it as something that's fun rather than embarrassing.

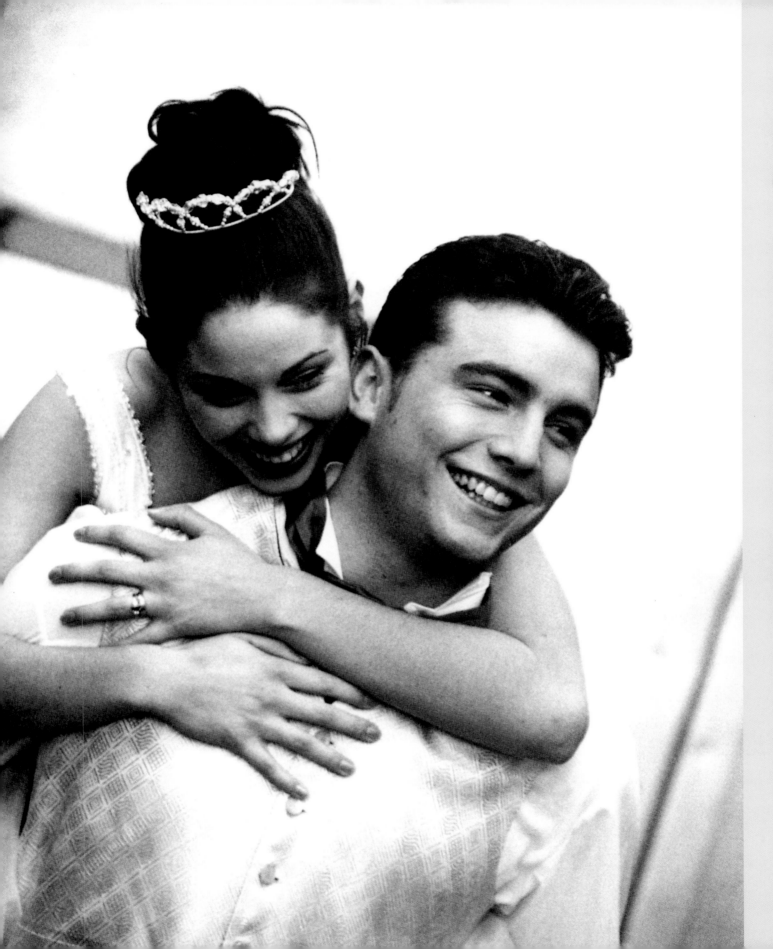

The planning and organisation that goes into most weddings is immense, with a wide range of people alongside the bride and groom getting involved and putting in an enormous amount of work to make the day as perfect as it can be. The wedding photographer has a duty to put just as much effort into making sure that everything runs smoothly from their end, because their pictures will ultimately be the only complete record of everything that happened. In my experience, photographs can make or break a wedding day.

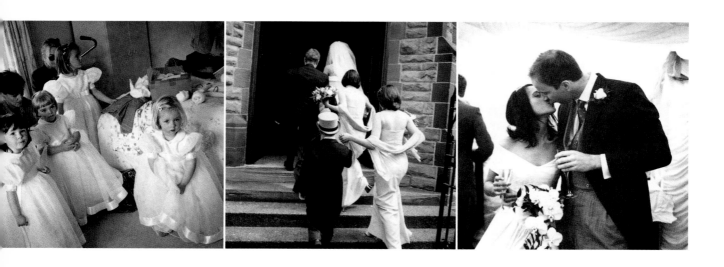

Wedding photography should capture the atmosphere of the whole day, from the last minute preparations on the morning through to the emotion and happiness of the service itself and finally the celebrations as the reception gives way to a party.

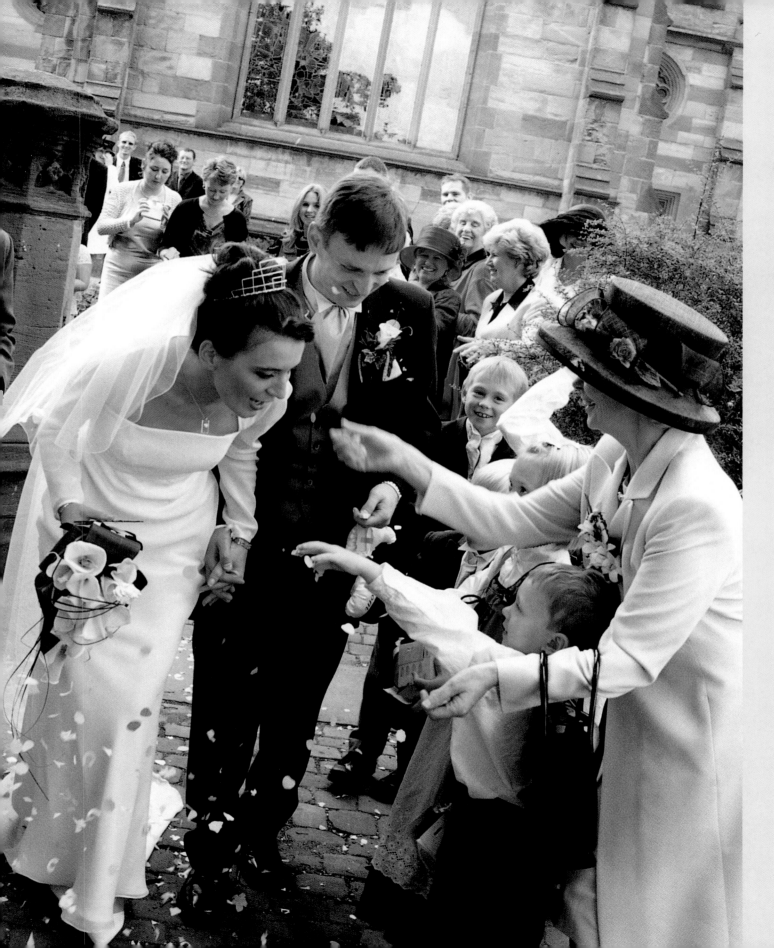

I consider it a great privilege to be able to photograph someone's wedding, because it can be one of the most inspiring, motivating and creative assignments that a photographer can have. Whether you see it like this, however, depends on whether you consider that it's nothing more than just another job, or whether you're determined to accept the challenge and to produce the very best results that you can from the occasion.

On the wedding day itself you'll find that so much is happening, and so quickly, that the only way you'll be able to cope is through careful planning well beforehand. Get this part right, however, and you'll find that you can really enjoy the day yourself, and if this happens it will show, and you'll find that those you are photographing will naturally respond to your enthusiasm.

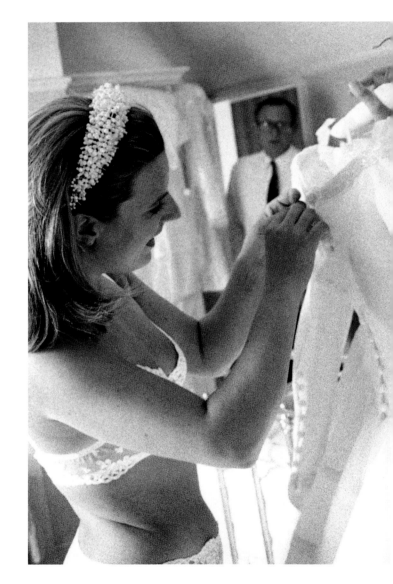

Shooting those early morning preparations at the bride's house is an essential part of your coverage, and these pictures help to build the story and to capture the growing anticipation.

Canon EOS 5, 75–300mm lens, Fujifilm Neopan 1600. Exposure 1/30sec at f/5.6

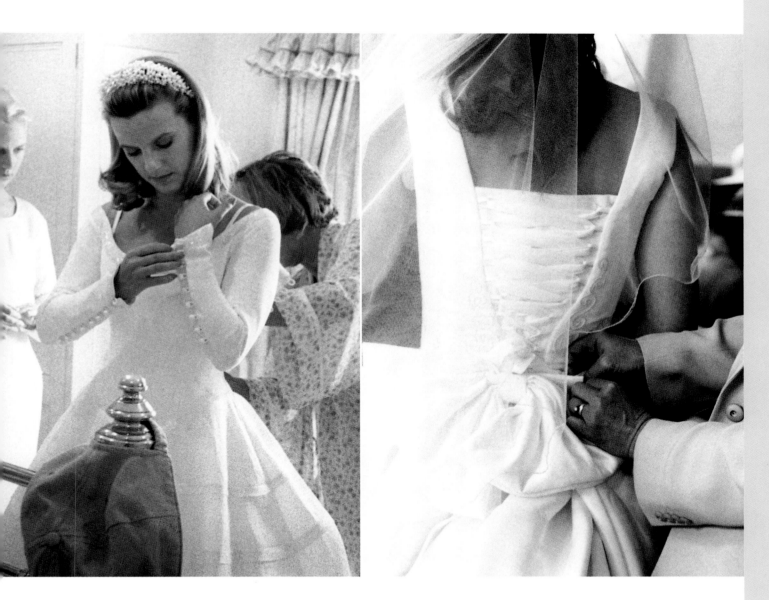

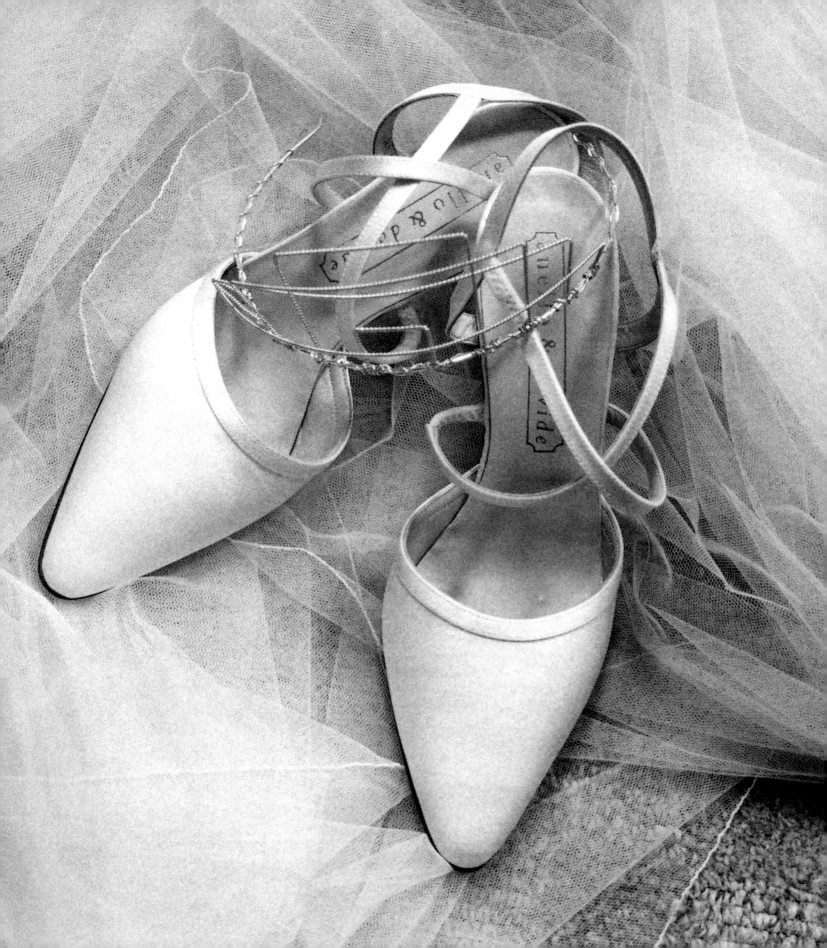

Wedding photography is not just about people, it's about capturing the detail. Every bride will have spent a great deal of time making sure that everything is right for her big day, and taking pictures of the back of her dress, the bridesmaids' shoes, the flowers and the cake will help you to produce a document that sets the scene and captures the atmosphere of the whole day.

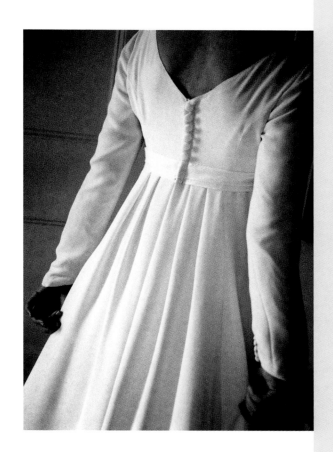

The bride will have chosen what she wears because she loves every little detail. Therefore it is important to photograph her shoes, tiara and dress before the actual wedding as you cannot be sure to get these pictures later.

Canon EOS 5, 75–300mm lens, Fujifilm Neopan 1600. Exposure 1/15sec at f/5.6

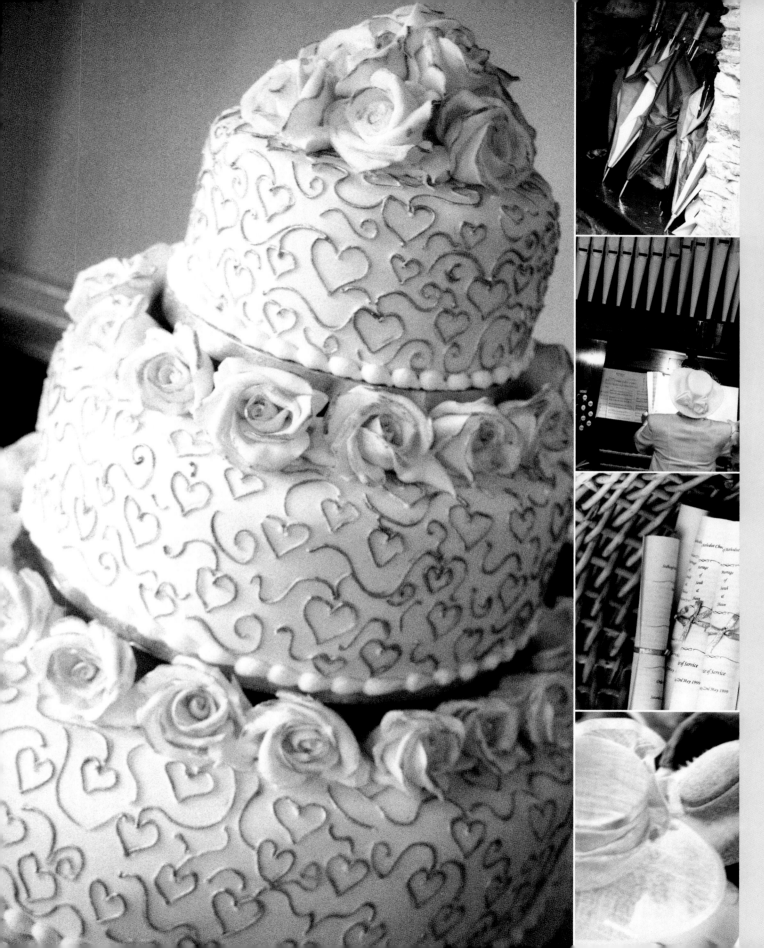

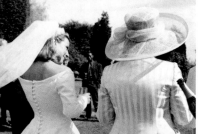

Creating candid pictures of wedding guests involves understanding people, and developing a subtle approach. Imagine if you were on location shooting grizzly bears! You couldn't just walk up to them and expect to get a good photo – you'd be more likely to get your head bitten off! If you're going to photograph people at a wedding you can't just impose yourself on them, you need to be able to relate to how they will be feeling on the day, and then act with appropriate sensitivity.

It's all about developing a relationship with your clients, so that they feel happy and comfortable with you.

It's a natural reaction to be guarded about looking at a camera – most people have usually had so many bad experiences that they tend to assume they will look awful in a photograph. Just watch the reaction of most guests once a video camera appears; everyone automatically turns the other way or ducks underneath it whenever it points in their direction. It is the same with a stills camera, and you have to act tactfully and discreetly so that people don't feel that you are intruding on, or invading, their space. This is why it is vital to do your preparation, and to build a rapport with the bride and groom before the wedding day.

In order to capture spontaneous moments like these, the photographer should be as unobtrusive as possible, so that people become oblivious to the camera.

If you're going to photograph people at a wedding you can't just impose yourself on them, you need to be able to relate to how they will be feeling on the day, and then act with appropriate sensitivity.

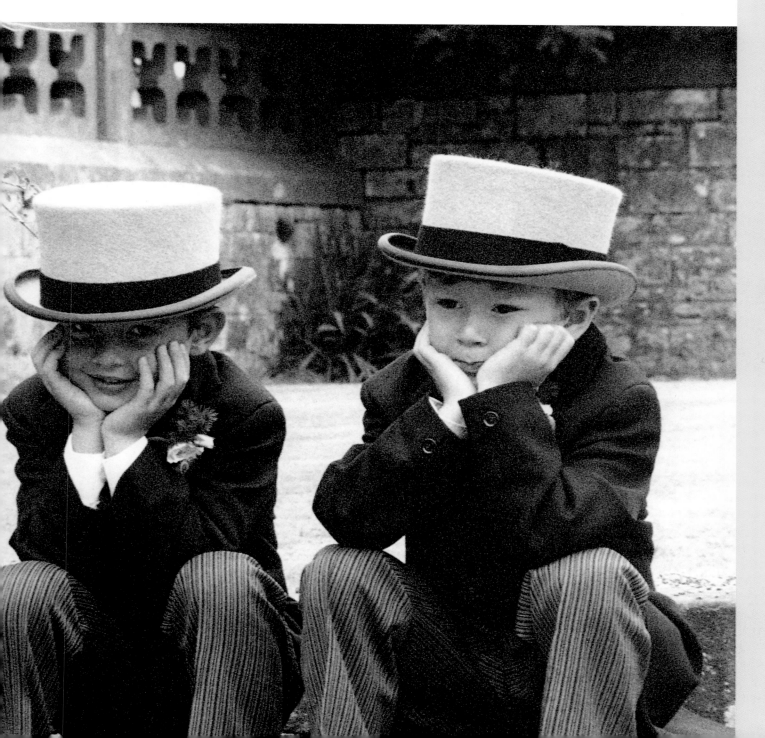

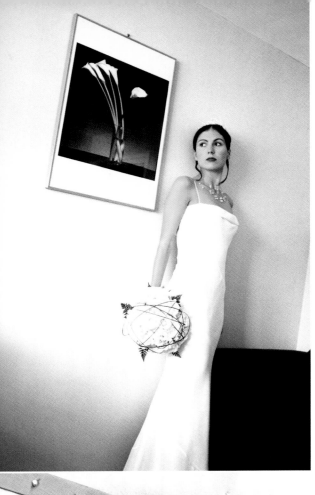

Whilst taking candid and unobtrusive pictures is very important, it is essential to understand that the bride wants to look like a model. She has probably spent months poring over glossy wedding magazines, and has become used to seeing pictures of professional models in wedding dresses looking radiant and happy. This is what she wants to look like herself, and it's your job to help her to achieve that goal.

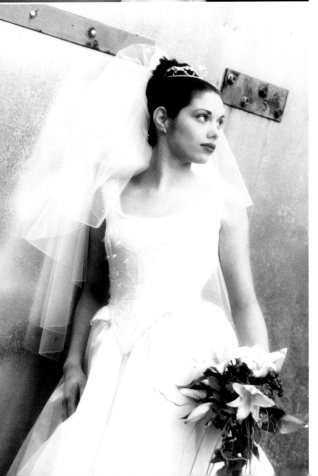

Pictures like these can be achieved at home just after the bride has got dressed, when her hair and make-up are perfect and the photographer can actually control the final result. Select your location while the bride is getting ready and then just place her within it. You'll probably only have five minutes so you need to be well prepared beforehand.

Hasselblad, 120mm lens, softar 1 filter, Fujifilm Provia 400. Exposure 1/60sec at f/5.6 (left), 1/500sec at f/8 (right)

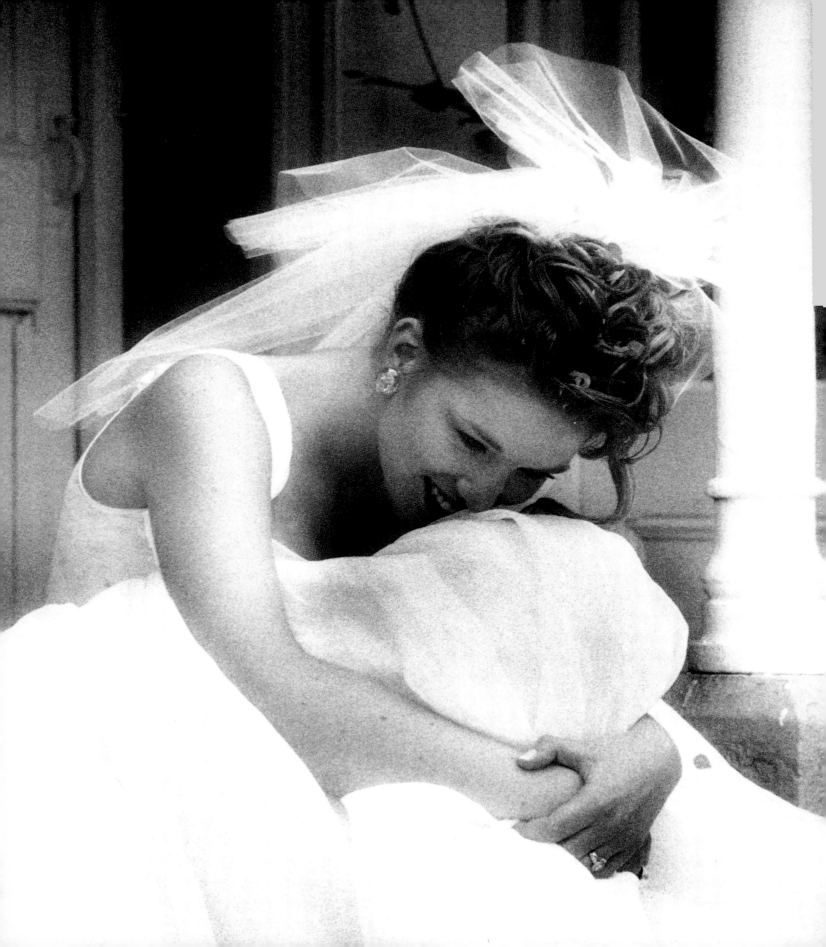

The key to successful wedding photography is the ability to capture how the bride feels as well as how she looks.

Pictures like this can be achieved at the reception when the bride will be relaxed after the anxiety of the church ceremony is over. This shot is part of a series of more composed shots and just happened as the bride reacted to the occasion. Using a 35mm camera with its automatic metering means the photographer is always able to take a spontaneous shot as it happens.

Canon EOS 5, 75–300mm lens, Fujifilm Neopan 1600. Exposure 1/125sec at f/5.6

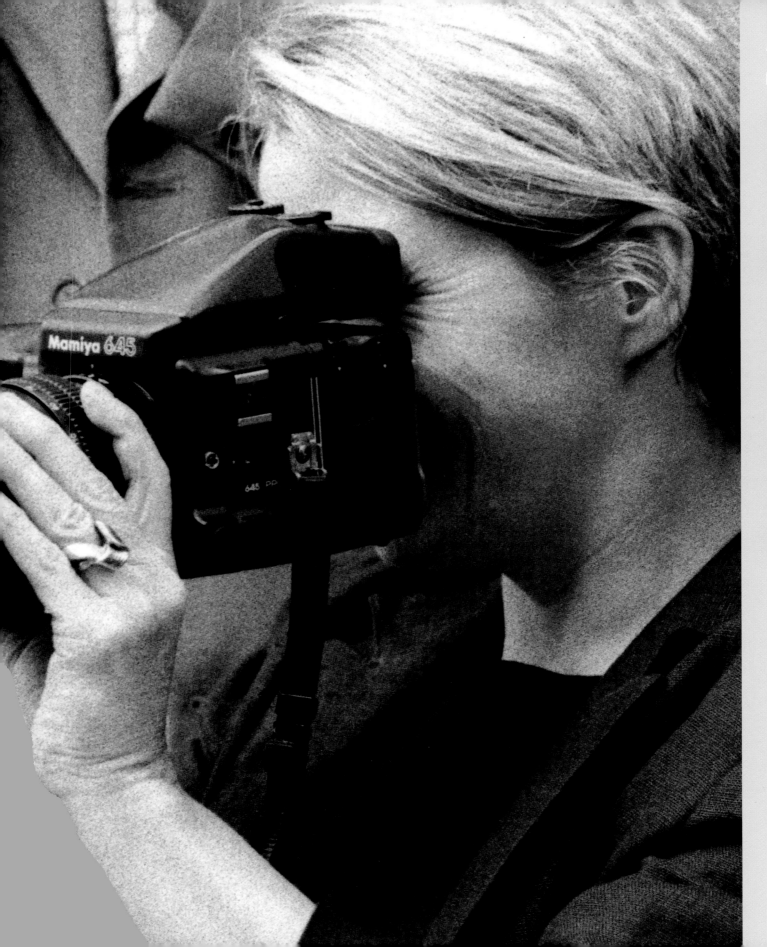

To ensure they get the best possible results from their wedding day you need to develop a relationship with your clients long before the actual event. The ideal way to do this is to spend time getting to know them by offering a pre-wedding shoot.

During your pre-wedding shoot the couple will learn to relax in front of the camera and to trust you.

Canon EOS 5, 75–300mm lens, Fujifilm Neopan 1600. Exposure 1/500sec at f/5.6

The pre-wedding shoot helps to:

Develop the relationship between the bride and groom and the photographer

Demonstrate how much fun it can be being photographed

Inspire confidence in you and your ability

Build trust enabling them to relax and not worry about having their photographs taken

Gain an understanding of your photographic style

Introduce new ideas of presentation in albums and frames

Provide an opportunity to experiment with hair and make-up ideas

Create an awareness of the variety and number of pictures that are likely to be produced on the wedding day

Build your reputation with their family and friends before the wedding thus ensuring that everyone will enjoy your company

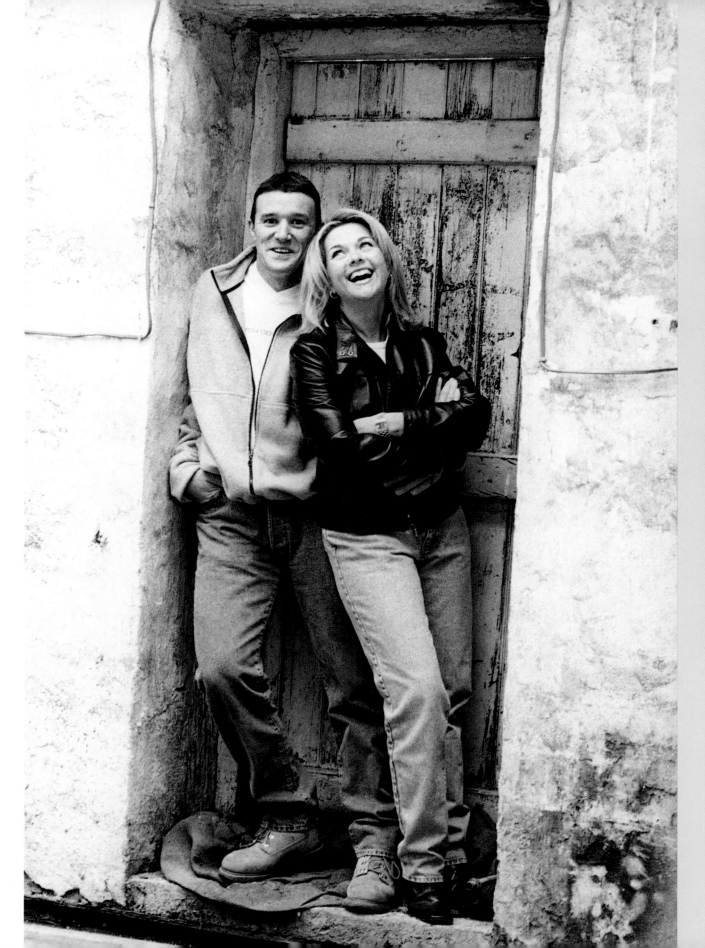

building a rapport with the bride and groom

41

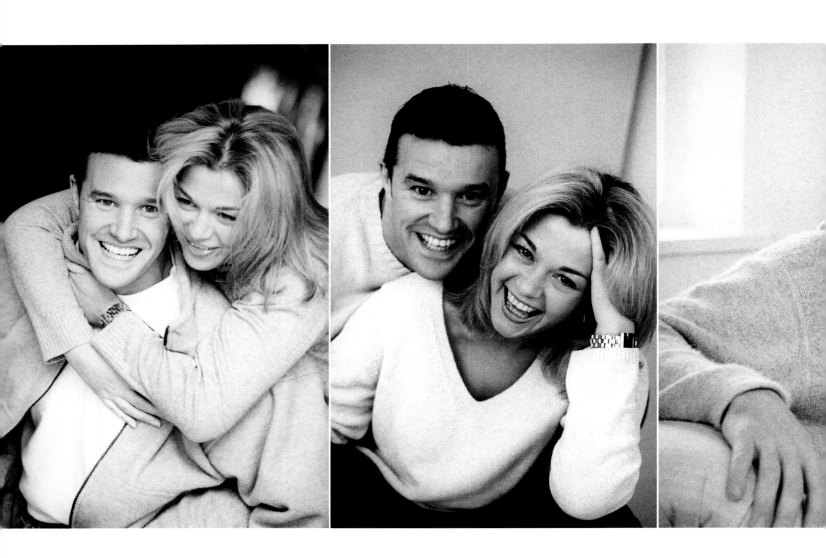

Try to take a variety of pictures that are spontaneous and sum up the intimacy between the couple.

Canon EOS 5, 75–300mm lens, Fujifilm Neopan 1600. Exposure 1/30sec at f/5.6

The idea of the pre-wedding shoot is to take pictures which show the relationship between the couple. The pictures should show them being close, happy, laughing and having fun.

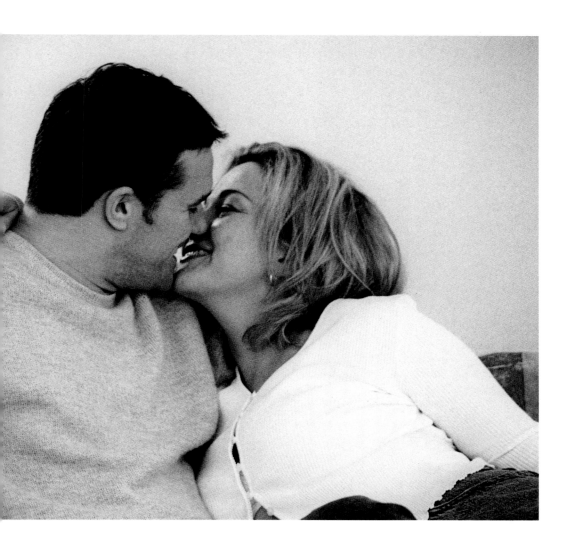

Most couples love black and white pictures which look candid and editorial, but don't forget to include some colour pictures as their parents will probably welcome the opportunity to have a picture of their child before they leave the nest!

Beautiful relaxed portraits such as this simply won't happen if everyone, including the photographer is getting into a panic and running behind schedule. Make things as easy as you can for yourself by checking all the details when making a booking and again just before the ceremony so that there are no unpleasant surprises on the day.

Hasselblad, 120mm lens with Softar 1 filter. Fujifilm Provia 400 cross processed. Exposure 1/500sec at f/5.6

An immense amount of planning goes into every wedding day and it is crucial that you are totally prepared so that you know exactly what is happening throughout the whole day, and are covered for every eventuality.

The only way your pictures can be relaxed, spontaneous and natural is if you are so well prepared before the wedding that on the actual day you can virtually just record what is happening and be relaxed enough to be ready for any unexpected fun shots that may happen.

It is essential to discuss all the details with the couple when they first book and again just prior to the wedding to check any changes.

What you need to know:

- **Is it a church or a civil ceremony?**
- **What religion or cultural background does the couple come from?**
- **Where will the bride be leaving from on the morning? Will it be from her home, her parents' home, or a hotel?**
- **How long will it take to get from the bride's home to the church?**
- **How long is the service likely to last?**
- **How long will it take to get from the church to the reception?**
- **What time is the meal being served?**
- **How many guests will there be?**
- **How many bridesmaids/ushers/best men?**

Tip:
It is also useful to find out whether the couple are having a video taken, and who is shooting it, as you may need to contact them beforehand simply to discuss arrangements and make sure that you both get what you want without getting in each other's way.

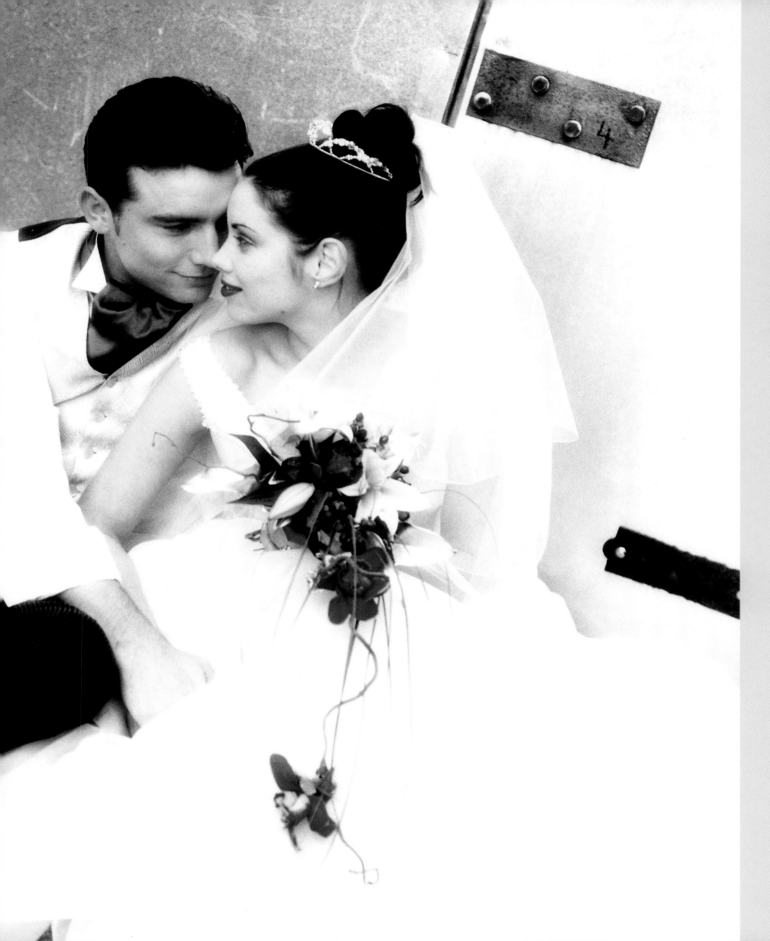

I usually enlist the help of my assistant and the best man or ushers to locate the people I need, and I can then set up the groups with the minimum of disturbance to the party.

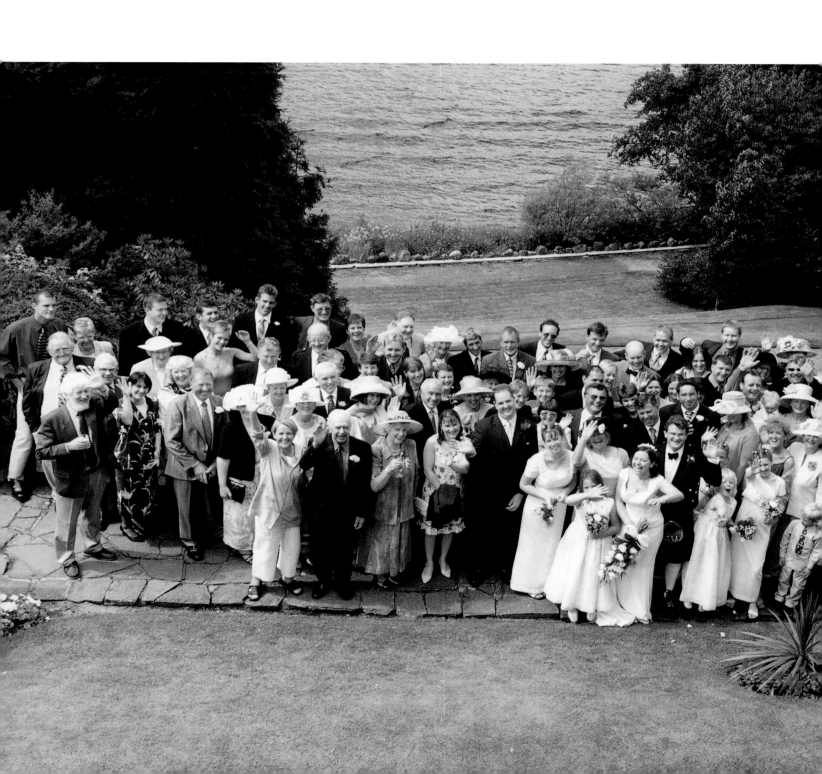

Although many weddings follow a similar pattern, each one will have its own individuality. This is particularly relevant where relationships are concerned. It is essential that you know who the key members of both families are.

It is vital at this stage to discuss group photographs with the couple so that they understand that if they require every relative photographing it will take ages and they are very unlikely to want to be held up with masses of groups on the wedding day. Many clients do not realise that it takes a long time to set up different combinations of groups and can be very boring for all the other guests.

I usually suggest that we only photograph immediate family and that it will take only 5–10 minutes to do this. I explain that if we photograph all the aunts, uncles, cousins etc it will take much longer, and most people do not like standing around. I usually solve the problem by suggesting we do one big group of everyone at the reception, and that I will be taking candid shots of most people anyway while they are otherwise occupied.

Putting all the guests together on one picture ensures everyone appears in a photograph and is much easier and quicker than taking lots of different combinations of groups.

The bride and groom often want
pictures of themselves with their
close friends and I find it is
easier not to do these straight
after the family groups, but to
split them up and to do them
later when everyone has had
a drink and is relaxing.

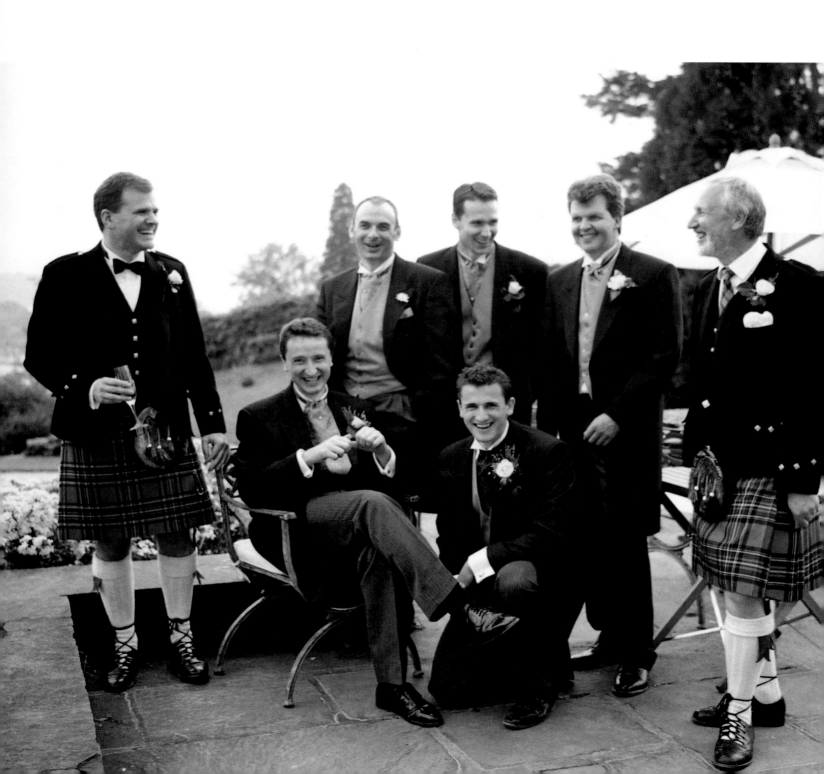

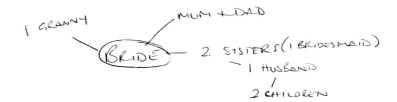

I GRANNY

BRIDE — MUM + DAD

2. SISTERS (1 BRIDESMAID)
— 1 HUSBAND
/
2 CHILDREN

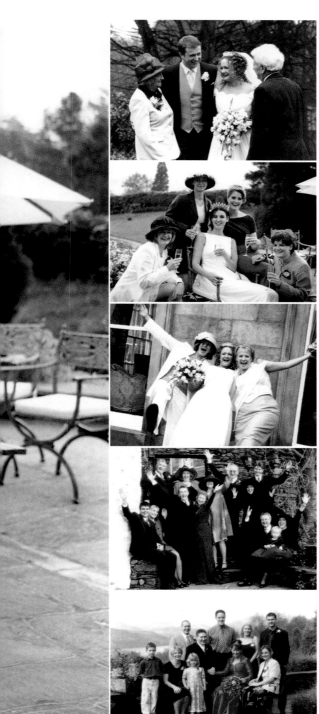

Today's couples often prefer candid photos to formal groups, but recognise that their parents like to have a record of their family on the day.

To keep the groups to a minimum I usually do just one group photo of each family, unless the bride and groom request them to be divided.

Possible problems:

Problems may occur when the couple have divorced or separated parents. Today, many couples have stepsisters and stepbrothers, and the variations can be amazing!

It is essential that you discuss these issues with the couple to avoid embarrassment on the day, as some parents will refuse to be in the same group as their ex! The couple will probably not have thought of the potential problems, and will be grateful that you have given them the chance to speak to their parents.

I usually suggest that the parents have one shot together with the bride and groom, and then an individual shot with their respective new partner.

NO GRANDPARENTS

MUM + STEPDAD

GROOM — DAD + GIRLFRIEND

1 BROTHER (BEST MAN)
— WIFE
— 3 CHILDREN

Tip:
I draw myself a little diagram of family relationships as it helps to see the situation at a glance.

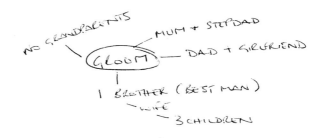

The top picture has been
arranged quickly and then
the subjects have been
photographed while they
are talking to each other,
rather than looking
at the camera, whilst the
pictures below and
opposite have been taken
with a zoom lens without
the subjects being aware of
the photographer.

Today's couples often prefer candid photography to formal groups... The way around this is to arrange people first and then shoot candidly as they chat together.

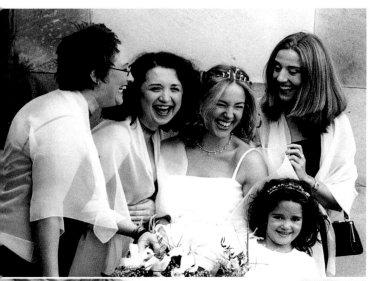

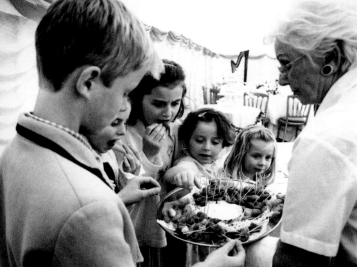

The term 'candid' is often misunderstood. True candids, which are taken without the knowledge of those being featured, can be very successful at weddings, but it is difficult to always achieve a decent picture of everyone in this style when so many people are together. The way around this is to arrange people first and then shoot candidly as they chat together. This will take a lot of the formality out of the picture, and it will give people something to do rather than looking at the camera.

Many people ask me to "just flit around and take people enjoying themselves" which sounds simple, but in fact is very difficult to achieve, because natural inhibitions ensure that guests will often turn the other way when they see the camera! The photographer has to build up a rapport with the people and if the guests have been impressed with your speed, efficiency and strength of personality throughout they are much more likely to relax and ignore the camera.

Tip:
Candid pictures are much
more easily achieved by using
a 35mm camera and zoom
lens so that you can stand a
long way away from your
subjects and take pictures
which they will probably not
even notice you taking.

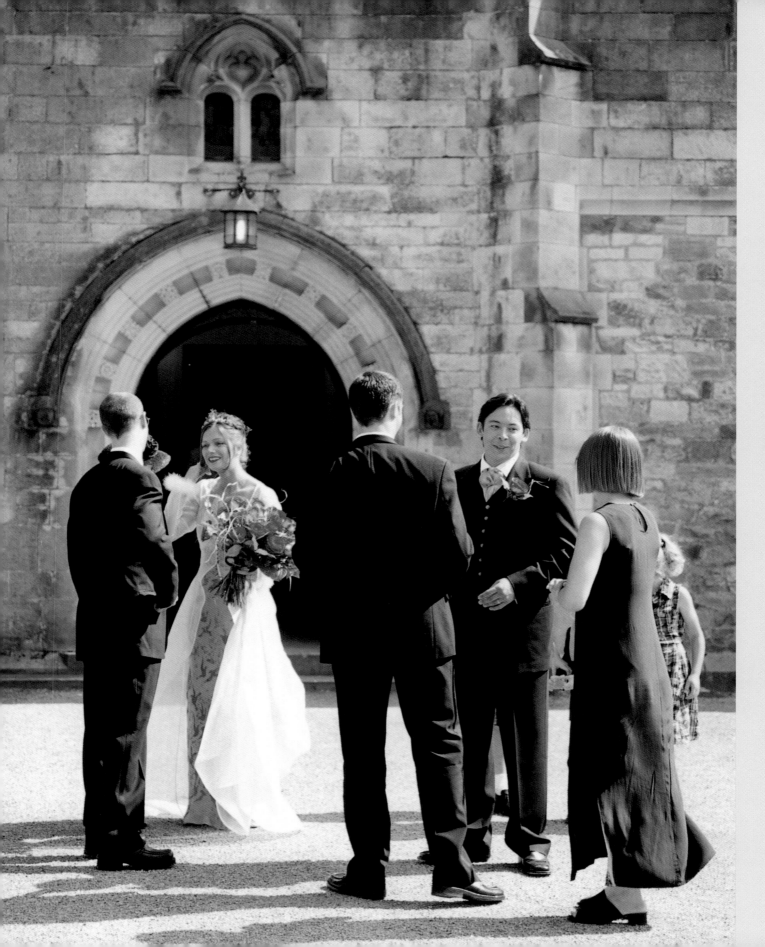

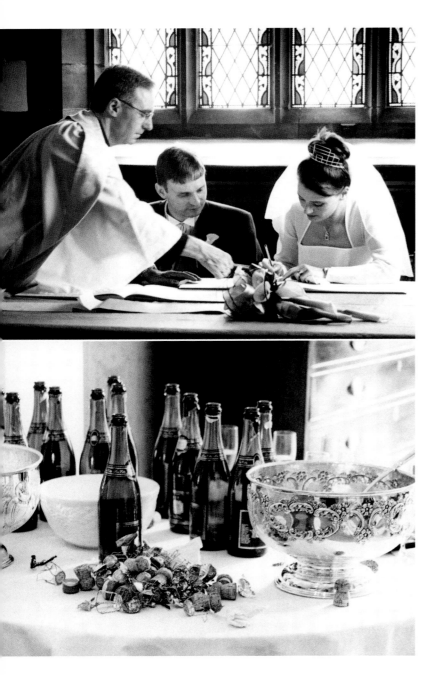

At home

Starting at the bride's home I want to capture the fun and excitement of everyone getting ready, whether they are still in their rollers, or ironing shirts! I often ask the bridesmaids to get ready first so that they can help to button up the bride's dress. This produces more flattering pictures than being in a dressing gown without make-up, which may look good from the photographer's point of view, but is often not the most flattering for the subjects. This is the time to photograph all the little details such as shoes, flowers, dress etc, then getting ready and finally taking the perfect shot of the bride before she sets off to church.

The ceremony

The second part of the day is often the most frantic part, where I need to be everywhere all at once and constantly thinking on my feet, watching for every little detail. The pace really speeds up now, and it's my job to make sure I photograph all the important people arriving and capture what the groom and his friends are doing before the bride arrives. I prefer to take candid black and white pictures in the church without being intrusive in any way, followed by very spontaneous colour and black and white shots of everyone chatting and throwing confetti outside the church.

The reception

I will usually take a few group shots at the church, but photograph most people at the reception when they are more relaxed and having a drink. I try to capture some of the atmosphere from the party; the couple socialising with their guests along with details of such things as place settings, cake and flowers.

Most weddings follow a structure that falls into three parts: the bride getting ready, the action at the church and finally the reception.

To produce a complete record of the day, it's important to cover every aspect. Black and white candid shots of the bride preparing herself are part of the mix and help to capture the atmosphere.

Canon EOS 5, 75–300mm lens. Fujifilm Neopan 1600. Exposure 1/30sec at f/5.6

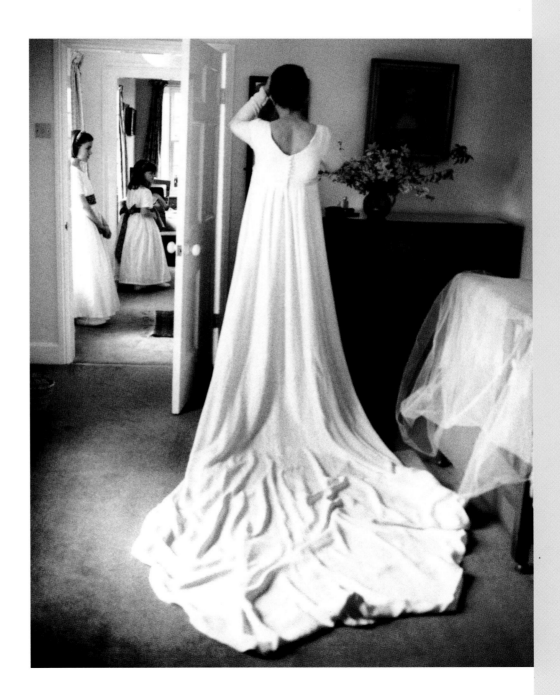

Tip:
If you see particularly attractive or unusual flowers or cars at a wedding, always ask for details so that you can then recommend them to other brides. These elements will enhance the backgrounds and details of your pictures.

The photographer is only part of the day. There are many other people involved in the running of the wedding, who are all equally important, and it is essential to network with these key people, to ensure that everyone can work happily together. As well as ensuring that everything runs smoothly, there are other benefits as well, because if you work quickly and efficiently, and never hold up the proceedings, the hotel manager is bound to recommend you to other prospective clients, as will people such as the car driver and the vicar.

The process works both ways. I always recommend a marquee company that has consistently high standards, and it helps me too because, if the marquee looks inspiring, then it will make a great background to my pictures. The same philosophy applies to cakes, stationery, table decorations and flowers, and I'm happy to pass on names of people that I know will do a good job if my clients ask me to. I'll also send companies who have participated in the day a photo if I think it may help their future business. They appreciate the gesture and it gives them something to show prospective brides.

I've also been known to telephone ahead to the hotel manager where the reception is being held to let him know that the wedding is running half an hour late due to the late arrival of the bride, and to warn him not to put the potatoes on yet! Little touches like this can mean a lot, and will help you to build a relationship with people that you are very likely to work with again.

I've also been known to telephone ahead to the hotel manager where the reception is being held to let him know that the wedding is running half an hour late due to the late arrival of the bride, and to warn him not to put the potatoes on yet!

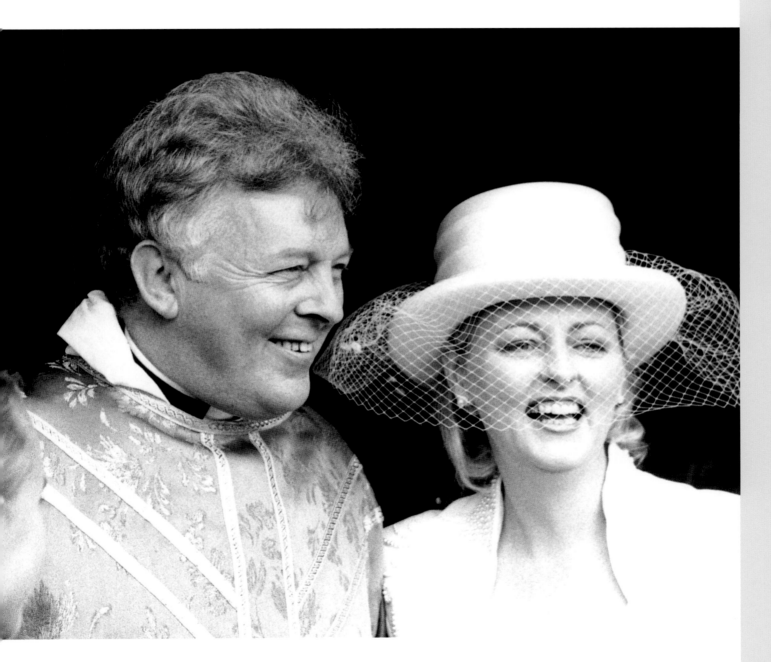

I hand-hold even my medium-format camera when I'm covering a wedding because this helps me to be flexible and spontaneous. I also use natural backgrounds where possible, and I look for ones that are plain and uncluttered.

The equipment you choose for the wedding should be simple and practical. Carrying huge cameras and tripods around can be exhausting and affects how spontaneous you can be.

I only ever use a tripod when I am in the bride's home, simply to get the perfect shot of the bride before she leaves. I find this often has to be shot in her bedroom with available window light, and I am often working at 1/15sec.

I never use the tripod other than for this. Today's clients want a documentary approach and this can only be achieved with simple, hand-held equipment.

At home

Black and white: Canon EOS 5 with 35–75mm zoom lens, often with the camera's own flash. Fujifilm Neopan 1600 film.

Colour: Hasselblad with 120mm lens on tripod, using available light. Fujifilm NHG 800 film.

At ceremony

Colour: hand-held on Mamiya 645 with 35–70mm zoom lens, and built in automatic metering system. Fujifilm NHG 800 film.

Black and white: on Canon EOS 5, as before.

At reception

Colour: hand-held on Hasselblad, as before, to alter format to square pictures, which adds variety and interest to the shots.

Black and white: on Canon EOS 5, as before.

Film:

Although it can vary, at a typical wedding I would use:
4–5 rolls of 35mm Fujifilm Neopan 1600
5–7 rolls of 120 Fujifilm NHG 800
2 rolls of 120 Fujifilm Provia 400 (cross-processed)

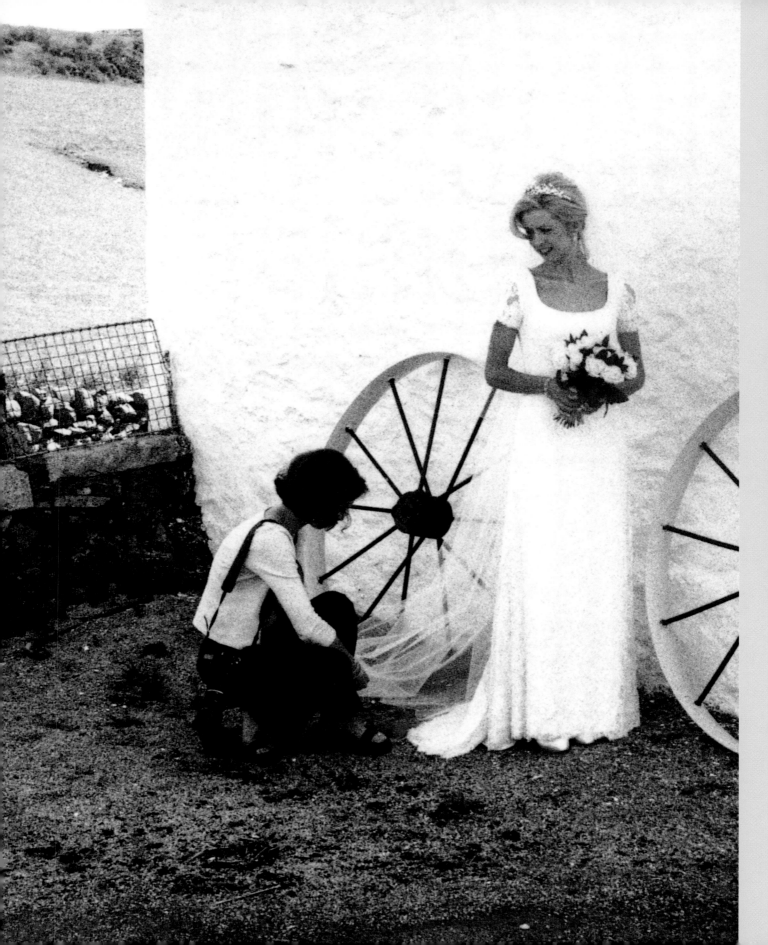

8.30 Lucinda starts to apply the make-up. Everyone is encouraged to be involved, by chatting, and drinking coffee and champagne! I love this part of the wedding when everyone is apprehensive about what is going to happen, and the excitement is mounting.

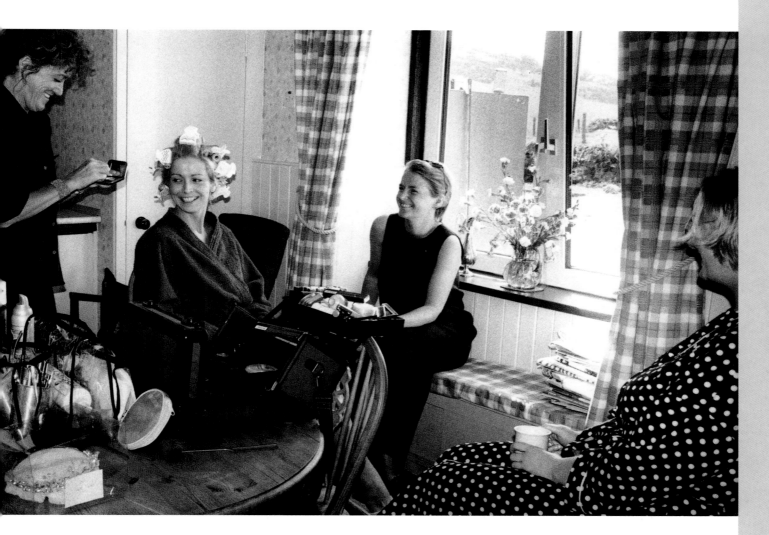

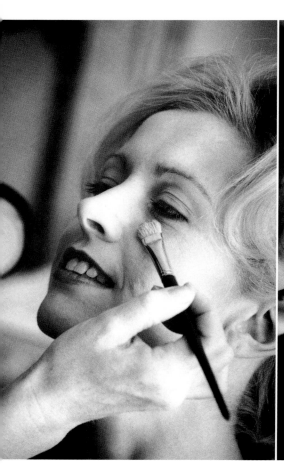

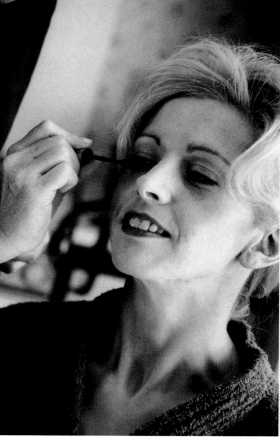

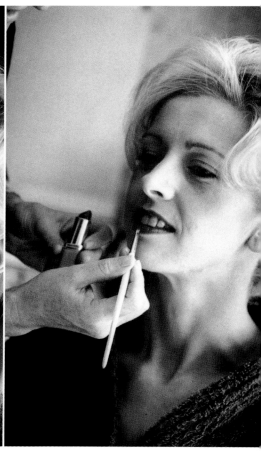

8.35 Lucinda applies foundation and concealer to even Liz's skin-tone and provide a base for her make-up to last all day.

8.55 Eyeshadow and mascara are applied to enhance her eyes and add a touch of colour to blend with the bridesmaids' lilac dresses.

9.15 Lipstick is applied using a fine lip-brush to define shape.

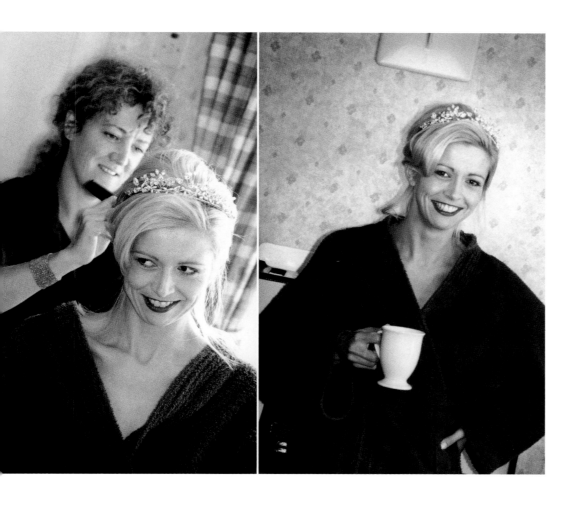

9.25 Lucinda styles Liz's hair to keep her tiara firmly in place.

10.00 Liz takes a coffee break!

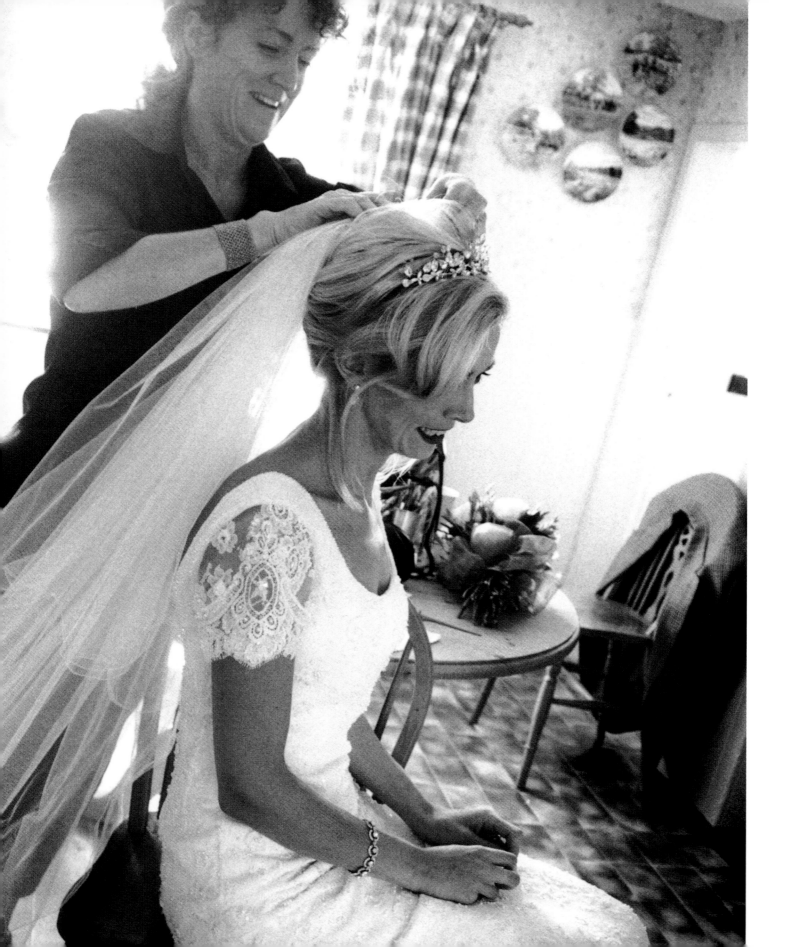

Always keep an open mind, and constantly think on your feet; there will be many more shots that will just happen and you need to be ready for them! The most successful pictures taken at home are the very candid ones which the bride often does not know are being taken.

It is not always possible to achieve all the shots you would like to take in the time allowed due to the many unforeseen circumstances that may occur, such as the bride being late back from the hairdressers and everything often happening all at once in the last half hour. However, the most important pictures are usually the candid "getting ready" shots, as any family pictures can always be done later in the day.

Depending on the situation I always try to take:

Detail shots, such as shoes, back of dress, presents, cards, flowers from the groom, jewellery etc. These shots can all be taken while the bride is getting ready.

Candid shots of people in rollers, make-up, ironing shirts, washing-up, drinking coffee and champagne.

Little bridesmaids dressing and sometimes being bribed into their under-skirts, ballet shoes and tights!

Older bridesmaids helping the bride dress including fastening cuffs, lacing back of dress, stepping into shoes – both close-up and wide-angle shots.

11.00 Liz is now in her dress and Lucinda completes the look by fixing the veil firmly into her hair.

The bride is ready and about to leave for the church, and already you have a series of atmospheric pictures that will tell the story of the early part of the day.

It is important to photograph the bride looking her best before she sets off for the wedding, as from this point on you are at the mercy of the elements.

It may rain or be windy, and although we are going to get some great pictures throughout the day this is a real chance to photograph her looking perfect.

If the bride and her family are all ready early, I will take some additional shots which will save me time later.

Suggested extra shots:

Bride and parents together, both formal and candid.

Bride and bridesmaids together, both formal and candid.

Bridesmaids individually, – particularly important if they are very young as they tend to tire easily later in the day.

Any opportunity such as this that will allow you to get ahead should be taken, because it all helps to relieve the pressure further down the line, and will contribute towards making the big day as stress-free as possible.

11.45 Liz is in the car and ready to set off for her big day!

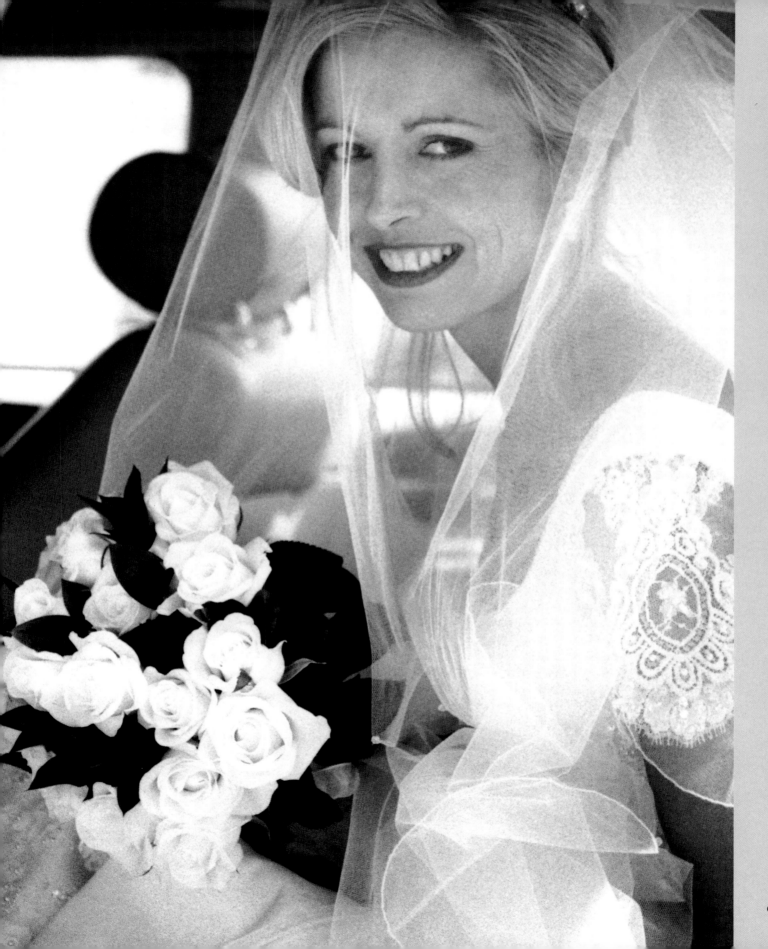

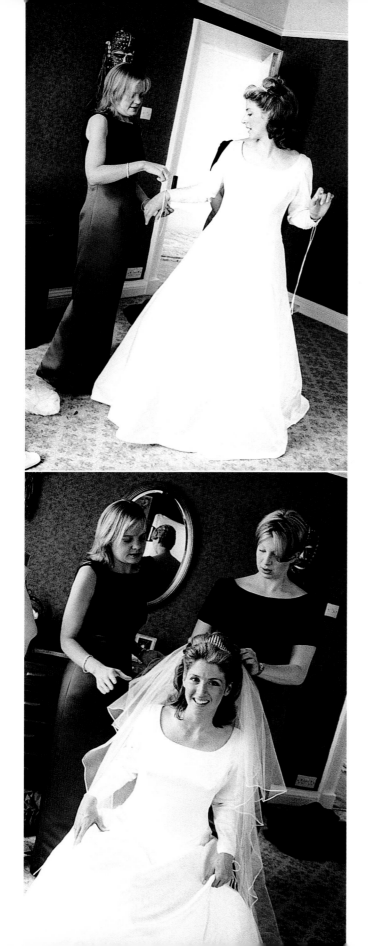

Spontaneous and lively pictures such as this can be produced at the bride's home as she completes her preparations for the day. A zoom lens enables you to switch from a wider shot to a close-up in a matter of moments without the need to alter your taking position, and this allows distracting peripheral details to be cropped out of the frame.

Canon EOS 5, 75–300mm lens, Fujifilm Neopan 1600. Exposure 1/30sec at f/5.6

The wedding day scenario:

Studio to bride's home – 30 minutes
Home to church – 10 minutes
Church to reception – 20 minutes
Start time – 11.15am
Time of wedding – 1.00pm
Start of meal – 4.30pm
Number of guests – 150
Estimated number of pictures – 150–200

10.00 Meet assistant at studio and load car.

10.15 Leave studio for bride's home, allowing extra time for unforeseen circumstances.

10.45–11.00 Arrive at bride's house deliberately early, throwing everyone into panic!

Introduce myself and my assistant to the family – hopefully get a cup of coffee!

Wander around the house and garden looking for locations (although often shoot in the bedroom as usually run out of time if the bride is late).

11.15 Start persuading people to get ready as I have to leave for the church in one hour.

11.30–12.10 Photograph everything that is happening, from the bride getting ready to the more formal shots of the family.

12.15 Pack car and go to church – usually in a hurry!

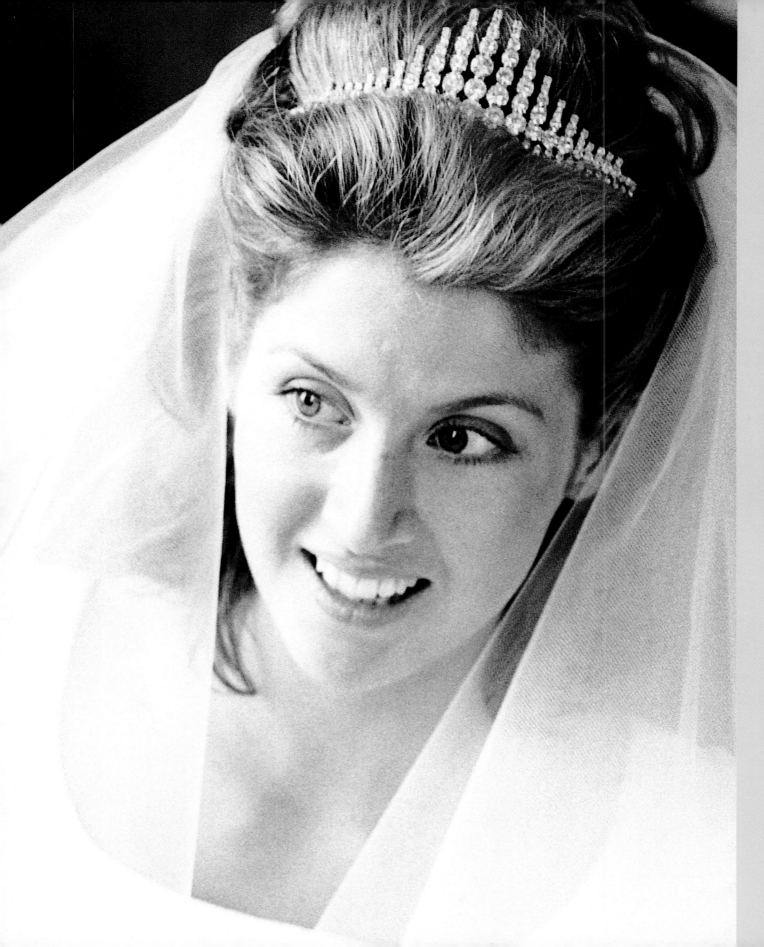

Preparation: the key word is <u>attitude</u>! I attend every wedding as if I am a guest, and dress accordingly.

I want to enjoy myself and feel part of the party. I need to be relaxed and focused on the format of the day, which is why I would never do another shoot before a wedding.

If everyone is ready in time, try to set up some pictures of the bride with her family before she leaves for the church, because this will take some of the pressure off later on. Ask everyone to start chatting so that their attention is focused away from the camera, and this will help you to produce more natural results.

Canon EOS 5, 75–300mm lens, Fujifilm Neopan 1600. Exposure 1/125sec at f/5.6

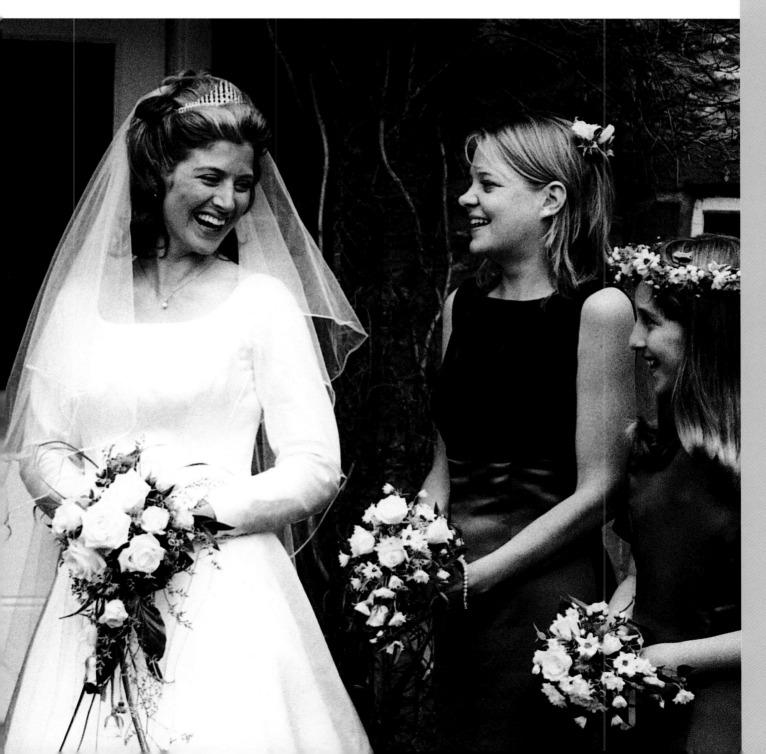

12.30 Arrive at church and park carefully making sure I won't be blocked in and can get my car out quickly after the service.

12.35 Leave equipment with assistant and go and find groom! If he's in the pub across the road, take photos as they leave for church.

12.40 Take photos of groom, best man and ushers chatting to people in the churchyard, candid pictures of guests arriving plus whole scene shots in colour and black and white.

12.50 Photograph bridesmaids and bride's mother arriving and mingling with guests.

Try to sum up the flavour of the day through your photographs. This picture of the groom and his best man setting off for the church included the pub in the background that they had visited beforehand, and these small reminders of the details of the occasion contribute greatly to the couple's enjoyment of the pictures.

Mamiya 645, 35–70mm lens, Fujifilm NHG 800. Hand-held, exposure 1/250sec at f/8

KINGS ARMS

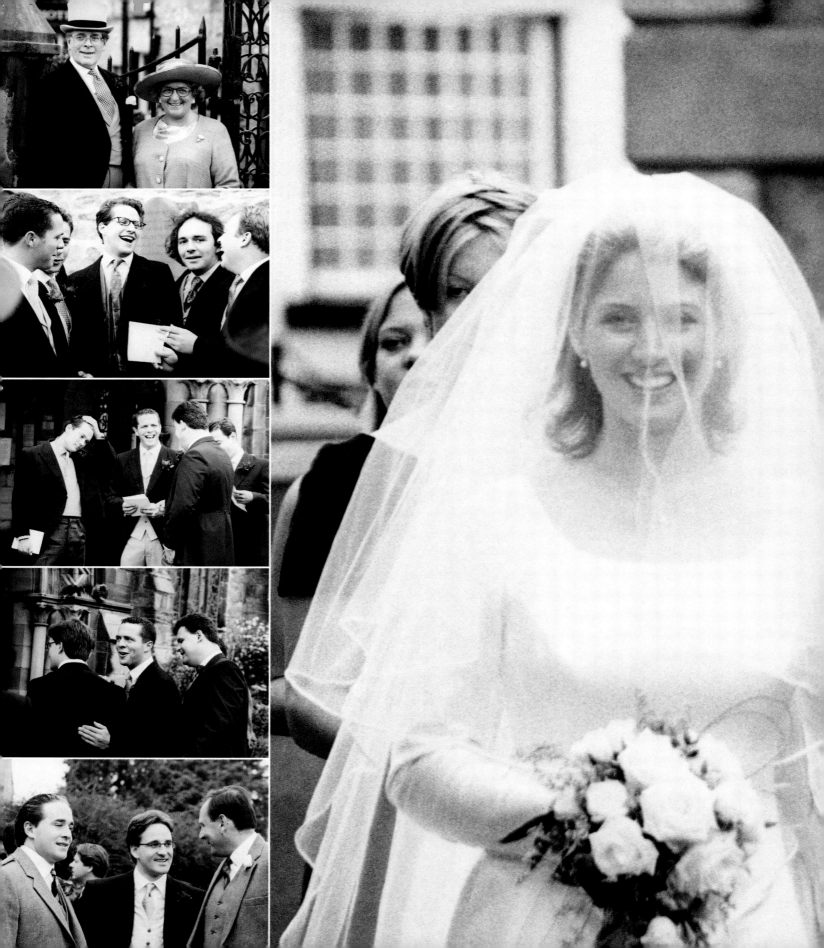

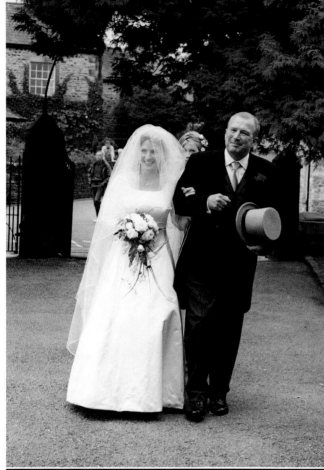

1.00 The bride arrives with her father. Assistant shooting black and white shots at this point while I am shooting colour, as it needs both of us to capture the action as it happens.

Colour and black and white shots taken as they arrive, and walk up the church path.

1.05 Arrive at church door – photos taken as it happens, while vicar is chatting to the bride and her father.

Candid snaps of bridesmaids tidying dress. The bride often looks back over her shoulder naturally – so be ready for it!

Those moments between a bride and her father as they arrive together at the church are very special and the pictures you achieve will be treasured, especially if they look spontaneous and relaxed. Look especially for the small details that will help to bring it all to life, and these will often occur when everyone but you thinks that the pictures have all been taken.

Mamiya 645, 35–70mm lens, Fujifilm NHG 800. Hand-held, exposure 1/250sec at f/8

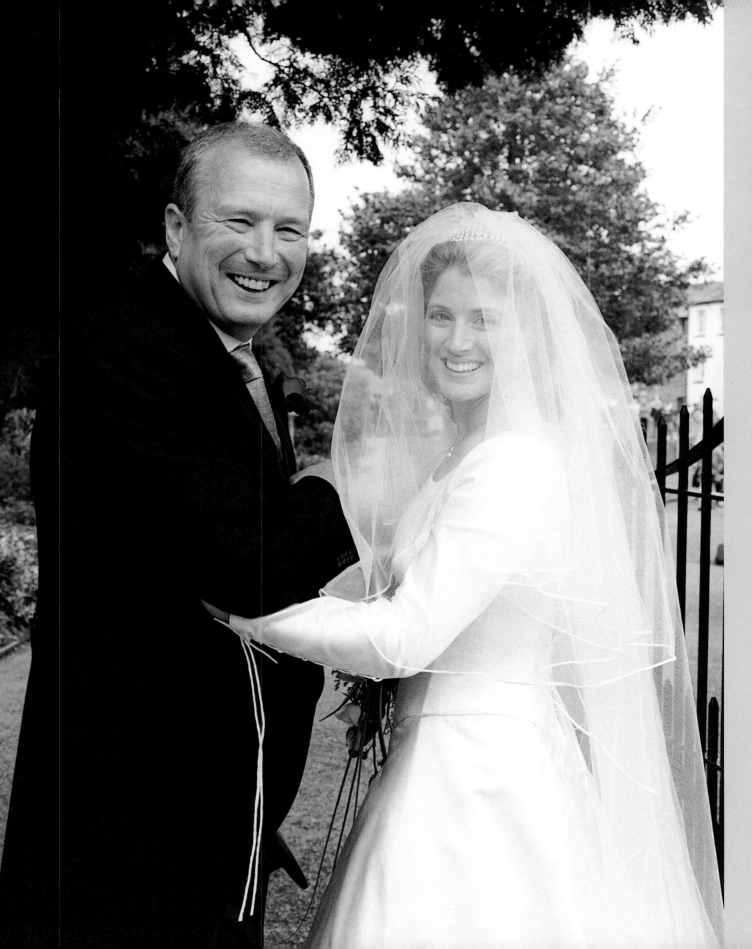

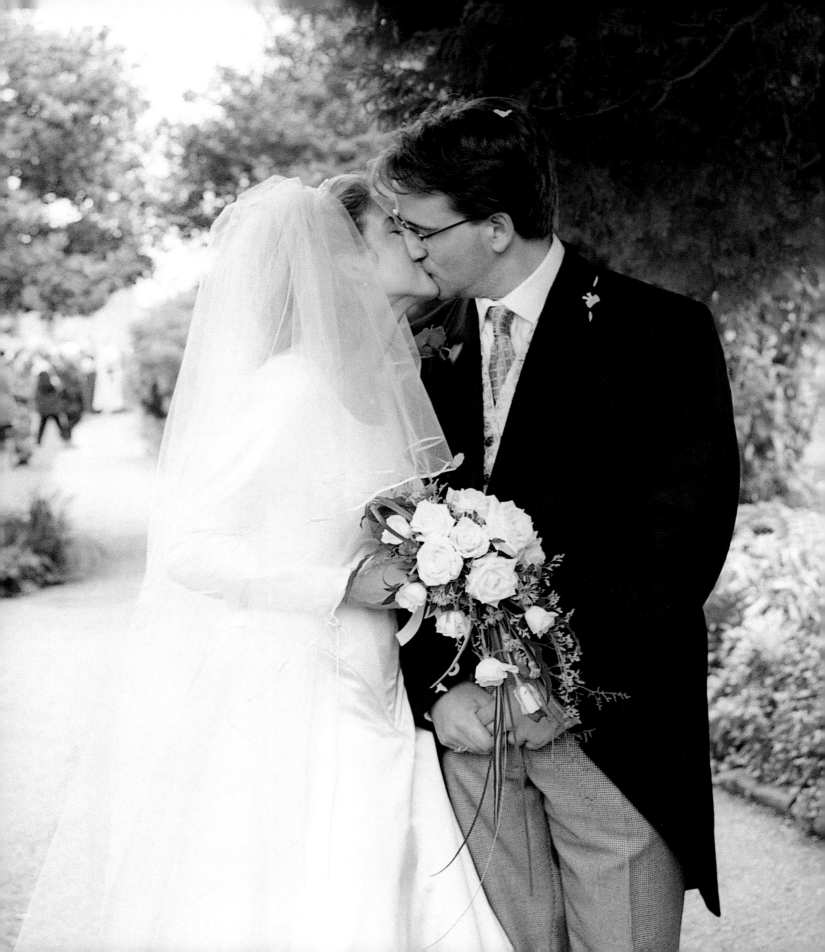

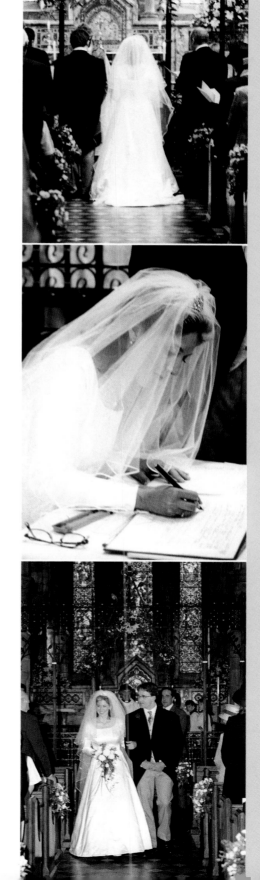

1.10 Take sneaky colour shot from back of the church with hand-held Mamiya 645 (no flash) during the first hymn so shutter cannot be heard (usually resting on a pew at 1/15 sec).

Candid black and white close-up shots throughout the ceremony using 35mm Canon with image stabilising lens, to prevent blurring at low shutter speeds (no flash).

1.35 Register shot taken candidly during actual signing, previously arranged with Vicar. No formal shot unless specifically requested.

1.45 Bride and groom walk down the aisle – one with flash (Mamiya 645 with Metz flash).

Discretion is the name of the game once the service is under way. The couple will want some record of the events inside the church and, providing that you work in a subtle way and reserve your flash for one picture of the new bride and groom walking down the aisle at the end of the service, you should be able to keep everyone happy.

Mamiya 645 with 35–70mm lens and Canon EOS 5 with 75–300mm lens. Fujifilm NHG 800 and Neopan 1600

81

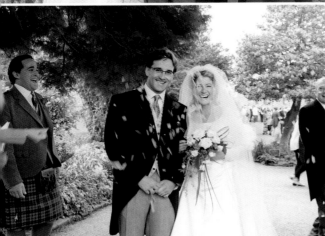

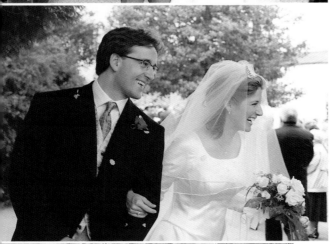

Many wedding photographers make themselves unpopular with guests by taking the bride and groom away from them for a lengthy period at the end of the service. I try to work instead in a candid fashion and my pictures of the couple being congratulated and showered with confetti by their friends and families are more natural and are always popular.

Mamiya 645, 35—70mm lens, Fujifilm NHG 800 set on automatic

1.50 Church doors – stop for one minute to take colour shots in church doorway. Assistant shooting black and white at the same time to record the action as it happens, and without delaying the proceedings.

1.51 Allow everyone out of church so they don't feel trapped, as at this stage they are keen to congratulate the bride and groom and take pictures.

2.00 Take candid photos of bride and groom chatting and kissing people.

2.20 Capture everyone throwing confetti, usually at the church gates.

2.25–2.30 Send assistant to load car while I photograph bride and groom getting into their car and leaving for reception.

2.50 Arrive at reception and photograph bride and groom getting out of their car. Do formal shot at front of car if requested, but mainly black & white shots of the action as it happens.

2.55 Use this 10–15 minutes to photograph the bride and groom together, while the other guests are still driving to reception and parking their cars. This way I will not hold up the proceedings.

This is the point where I may use the Hasselblad to take some cross-processed shots, if the location is suitable.

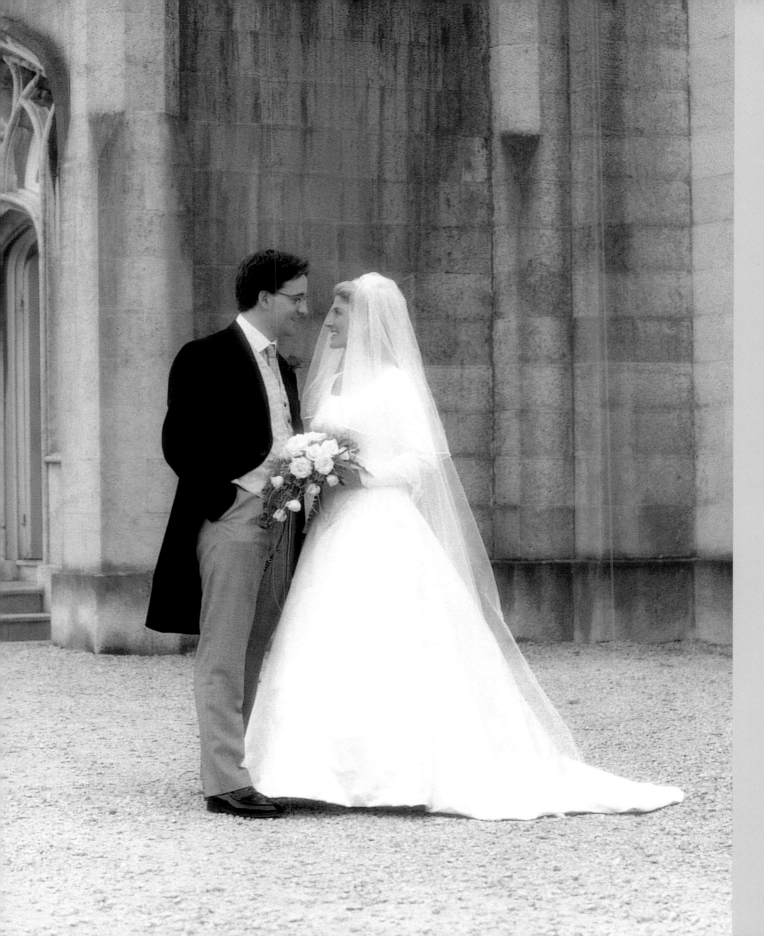

3.10 Let bride and groom greet their guests informally, while I take candid shots as it happens.

3.25 Inform the ushers/best man that we are going to do some group shots in five minutes and ask them to help find the various people we will need.

3.30 When the time feels right, I ask the bride if she would like to do some group shots now.

3.35–3.45 Allow ten minutes to do group shots – make it fun and let guests take their own pictures, so they become part of the experience.

3.45–3.55 Accommodate the various shots the bride and groom suddenly decide to have! Possibly do large group of everyone if previously requested.

4.10 Go to reception area without the bride and groom, and take detailed shots of cake/glasses/place settings etc, usually in black and white but also in colour for ultimate cross processing if they are very bright. I would take a shot of the cake with the bride and groom if requested, but find this is very rare nowadays.

Group shots can drag on and become terribly formal, so I try to encourage everyone to relax and to enjoy the process as much as possible. The days of everyone adopting a stiff pose for the occasion are thankfully long gone, and instead there's an air of celebration that adds to the atmosphere of the pictures.

Mamiya 645, 35—70mm lens.
Fujifilm Neopan 400 and NHG 800

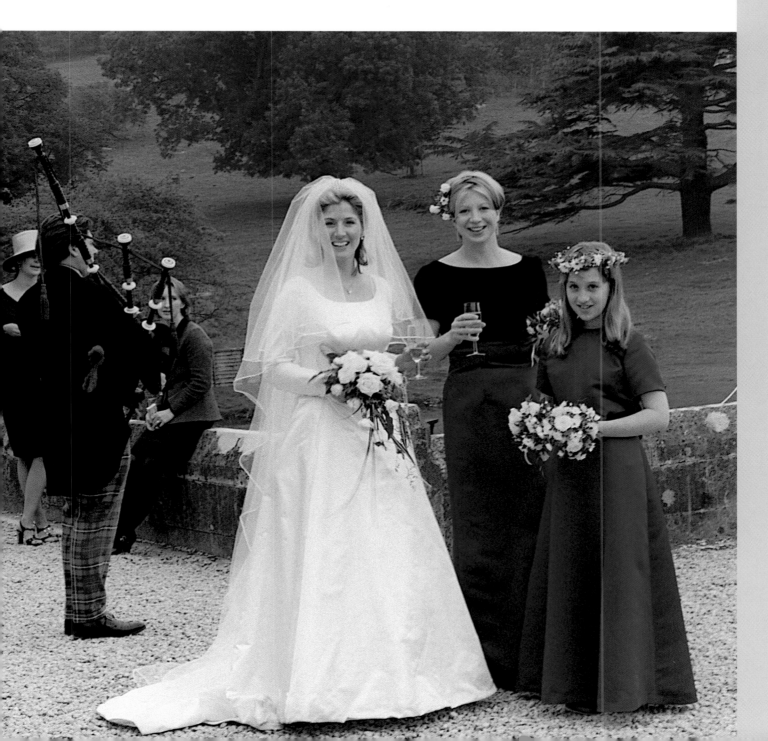

While the guests are chatting you may get the opportunity to take candid pictures of people which they will much prefer rather than posing for the camera.

Everyone is usually so preoccupied with congratulating the happy couple and in meeting up with friends and relatives that the last thing they want to do is to stop for a formal picture. Candids are much more fun in any case, and I simply move around the crowd and take pictures of the guests. The results are invariably happy and relaxed.

Canon EOS 5, 75–300mm lens, Fujifilm Neopan 1600. Exposure set on automatic

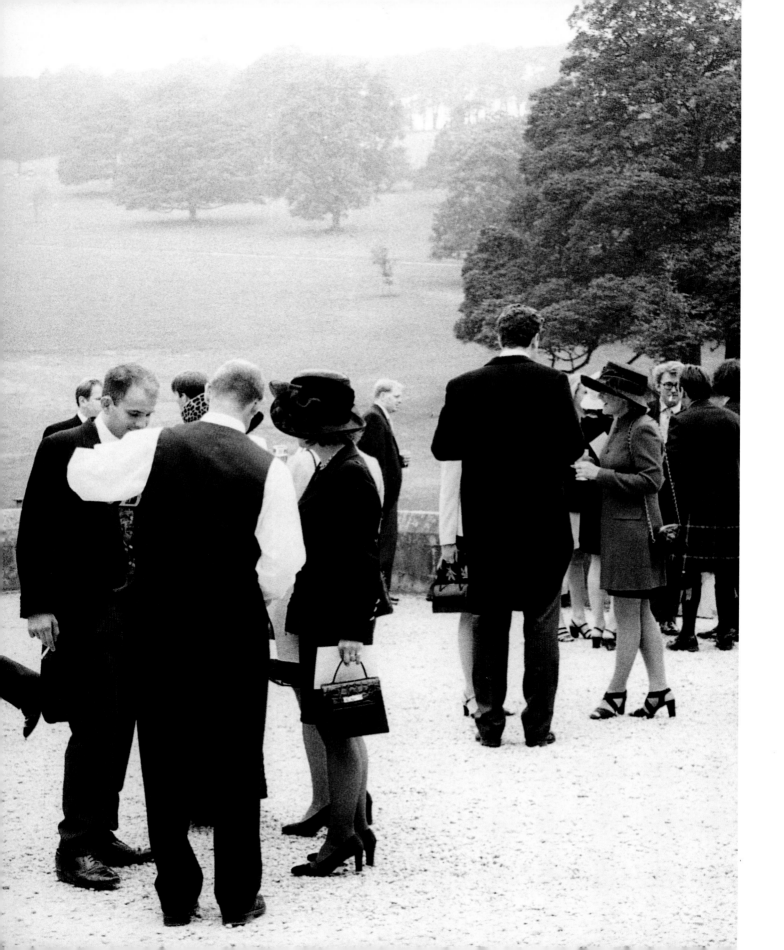

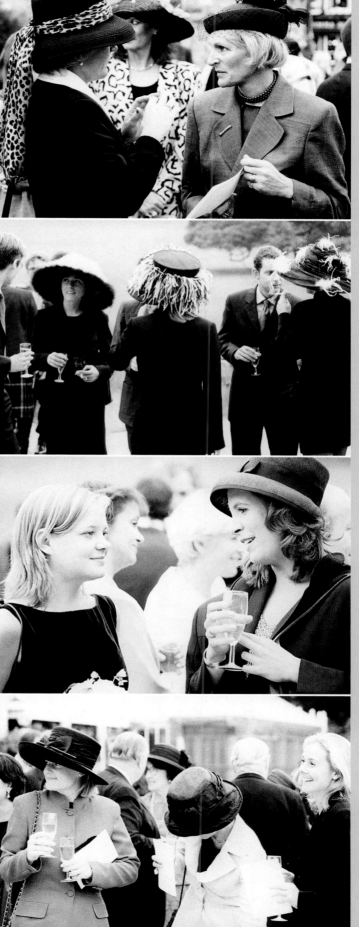

4.20 Have a drink and mingle with guests in case any other shots are suddenly requested. Take more candid shots of people chatting.

4.30 Leave when bride and groom start line up into reception, unless an agreement has previously been made to photograph meal and evening reception as well.

Everyone has their own memories of a wedding day, and informal pictures of the guests help to bring it all back. Most of the time those I am photographing are unaware that they're on film, and the pictures consequently have a natural and relaxed feel to them.

Canon EOS 5, 75–300mm lens, Fujifilm Neopan 1600. Exposure set on automatic

Checking the locations is an integral part of the planning and preparation that goes into shooting a wedding. If you are totally familiar with the venue then you will be able to relax and take your photographs much more quickly and efficiently.

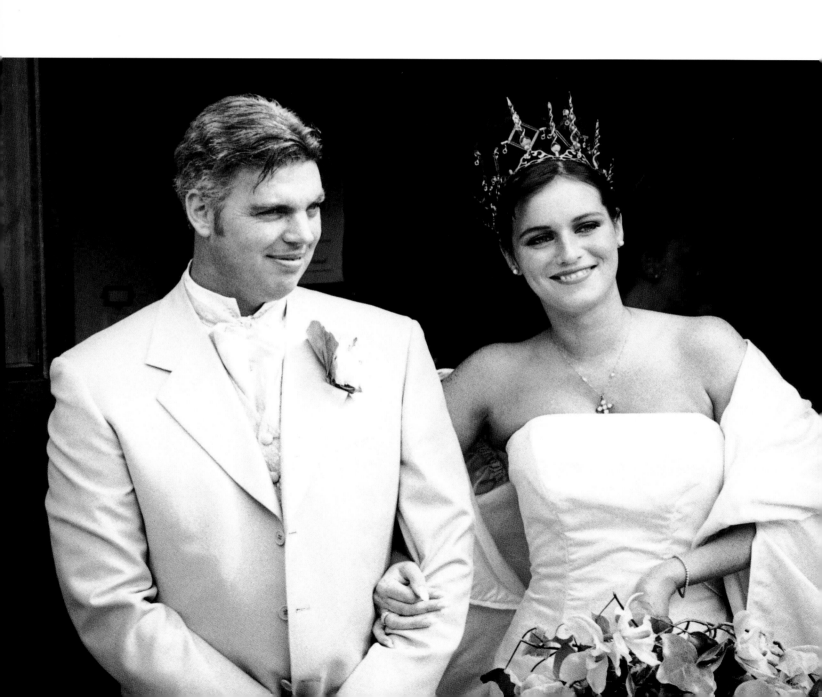

Not all locations are ideal for beautiful photographs. In cases where churches are not very attractive it is essential to try and take pictures which do not show the background. This shot establishes the scene, but at the cost of highlighting the modern church. The pictures below are taken in exactly the same place but great care has been taken to avoid showing the background, by cropping in tightly and shooting in black and white.

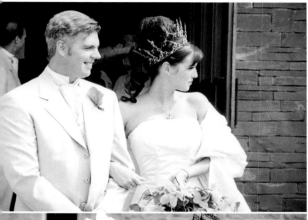

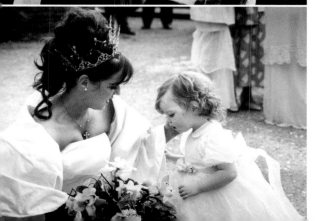

Know your location

It is important to know exactly what is available to you in terms of location. If the church is ugly your pictures will look unattractive unless you can crop carefully and avoid showing the whole background. The church doorway is ideal, as the background will go dark and enhance the subjects, as shown in the picture on the left.

In the case of very attractive churches, the problem can be too much choice, and it is important you pre-select where you are going to shoot, to avoid getting carried away and using too many locations! Look for places which other people may not think of, so that your pictures look different. For example, most of the guests will take their photos of the groom before the wedding in the church doorway, which means the couple will have seen lots of pictures like this – try to take yours at the gate instead.

If the bride's bedroom is small and dark, I will often take a few candid shots of the preparations and then ask the bride to put her dress on in the sitting room where there may be more light. This provides more space, a different background and adds variety.

Look for alternatives

If the bride and groom request special pictures on their own, try to select a different location from where you will photograph the groups or guests, to add variety to the wedding album. Always try to select locations which are very close – taking the couple away from their guests for a long walk is very unsociable, and everyone feels part of the proceedings if they can watch what is going on. It also helps you to work faster.

If the wedding takes place at home in a marquee, visit the bride's home two days before, to check where the marquee has been placed, because the previously lovely garden may now have been completely covered, and you will need to look at how much light is being blocked out by it etc. You also need to know where the action will be taking place, as there will probably be a plan as to where the bride's car will arrive, and where people will be mingling etc.

Making a contingency plan

The weather can make a big difference to where you are able to take your pictures. It is vital to know what you are going to do if it rains. Check whether there is a covered porch at the front of the hotel, or a conservatory you could use for small groups or pictures of the couple. Many photographers use the interior of the church, but this often produces very austere backgrounds. Most couples will prefer natural shots taken as they rush out of the church under umbrellas – it is not essential to have perfectly posed shots under beautiful trees any more, so don't panic if you can't get them!

Look for different locations depending on the time of day – where will the sun be?

If you have checked out the locations carefully before the wedding, you will have the confidence on the day to decide quickly where to take your pictures in any eventuality.

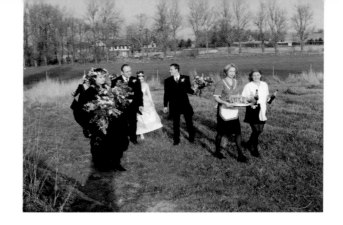

The reality
This picture shows the reality of the stubble and mud, together with bare trees and houses in the background.

Winter weddings can present a special challenge because, with the leaves fallen from the trees and vegetation died back, the scenery will often be very bare and unattractive. However, even these circumstances can be used to advantage and, through careful positioning, a picture can be created based around something that, at first glance, appears to be unusable. In the examples here I used what, essentially, were just tufts of grass in a ploughed field, to provide interesting pictures.

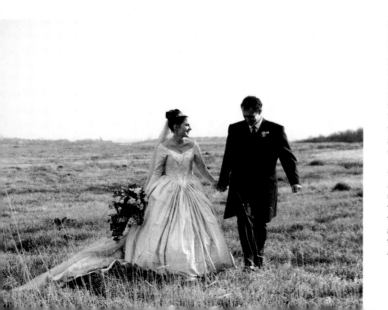

Use black and white to unify
I asked the couple to walk towards me while I crouched down behind a few strands of long grass. The result was quite subtle, but by including the grass in the foreground I was able to create the illusion of a much healthier crop, which in turn helps to take the eye away from the spartan nature of the field behind. The use of black and white film ensured that the rather jarring contrast between the green grass and regular patches of bare red earth could not be seen.

Creating an illusion
A combination of careful cropping, and a repositioning of the couple behind the only tuft of grass in the field, created the illusion that they were standing in a field of long grass. I cross-processed the film to bring out the colours and to give the grass a richer appearance than it really had.

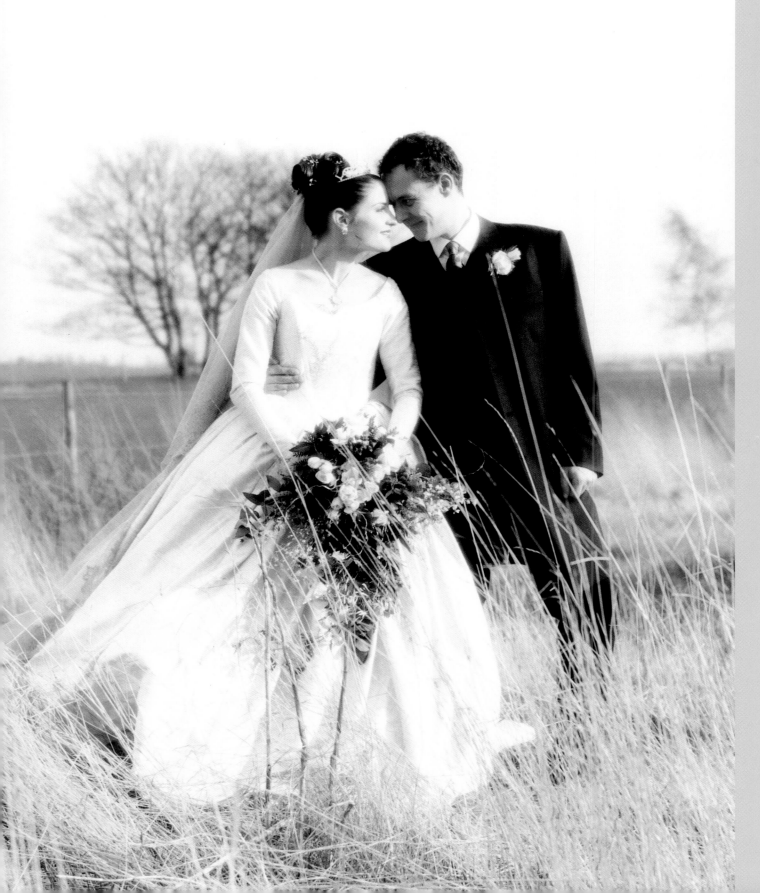

Working with bright sunlight

On a bright sunny day, when people are out in open spaces without much shade, I often try to make sure that they are positioned so that they have their backs to the sun. This prevents harsh shadows on the faces, and allows the subjects to be comfortable, but it does create exposure considerations that have to be addressed to avoid major problems. A camera that automatically calculates exposure for you will be fooled by the light streaming into the lens into setting a reading that will give a dark and extremely unflattering result. It's essential that the faces of your subjects should be correctly exposed, so this is where you should be taking your reading from. Either walk up close to them and take a reading from a hand-held meter held close to them or invest in a spot meter, which will allow readings to be taken from very precise areas of the scene. Setting this exposure will cause the background to bleach out just a little, but this can be a pleasing effect and, as a bonus, you'll find that sunlight will just touch the edges of your subject's clothes and will create an attractive sheen there. If you look closely here you can see sunlight just catching the groom's forehead, the bride's shoulder and the arm of the lady throwing confetti.

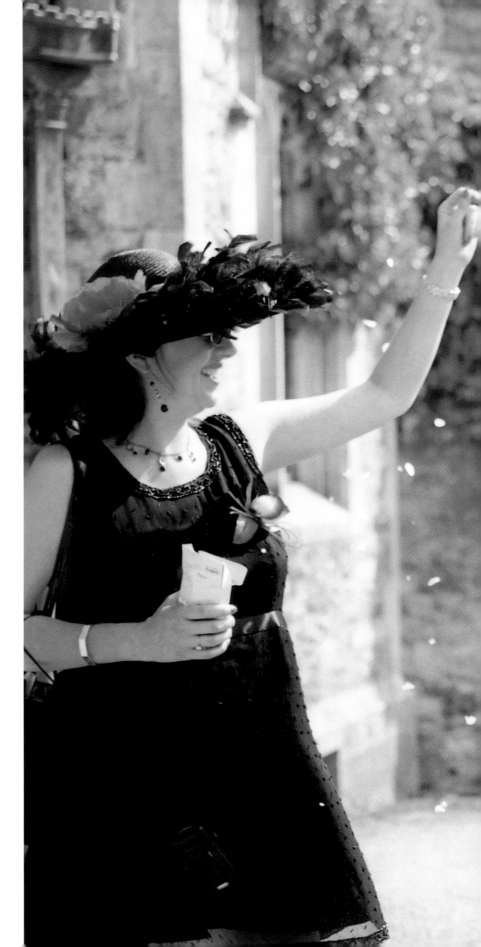

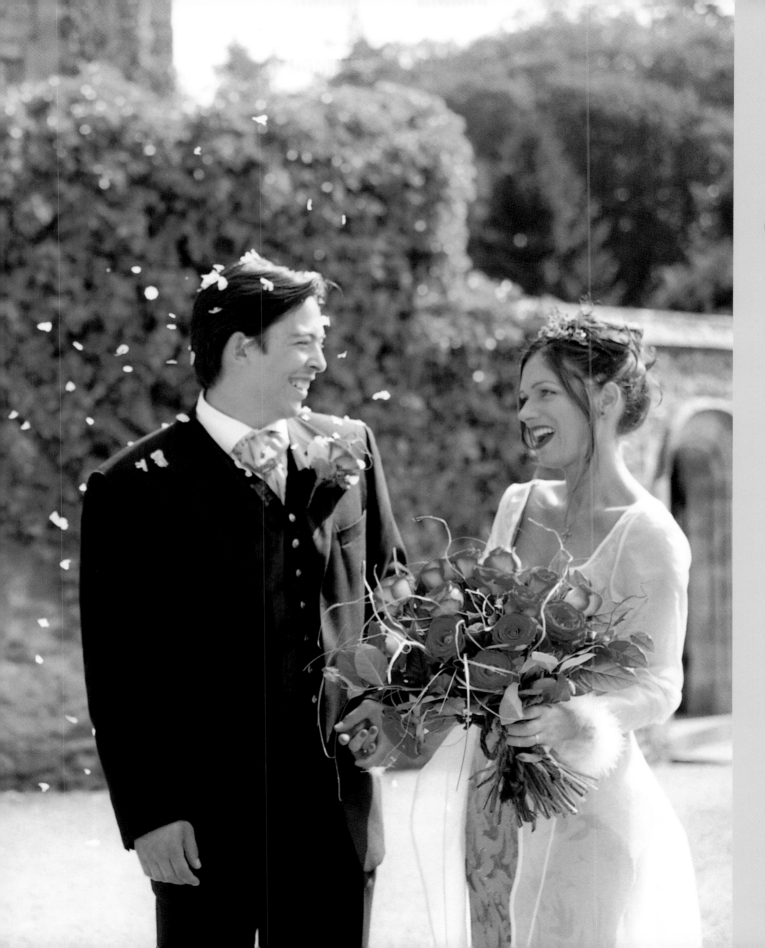

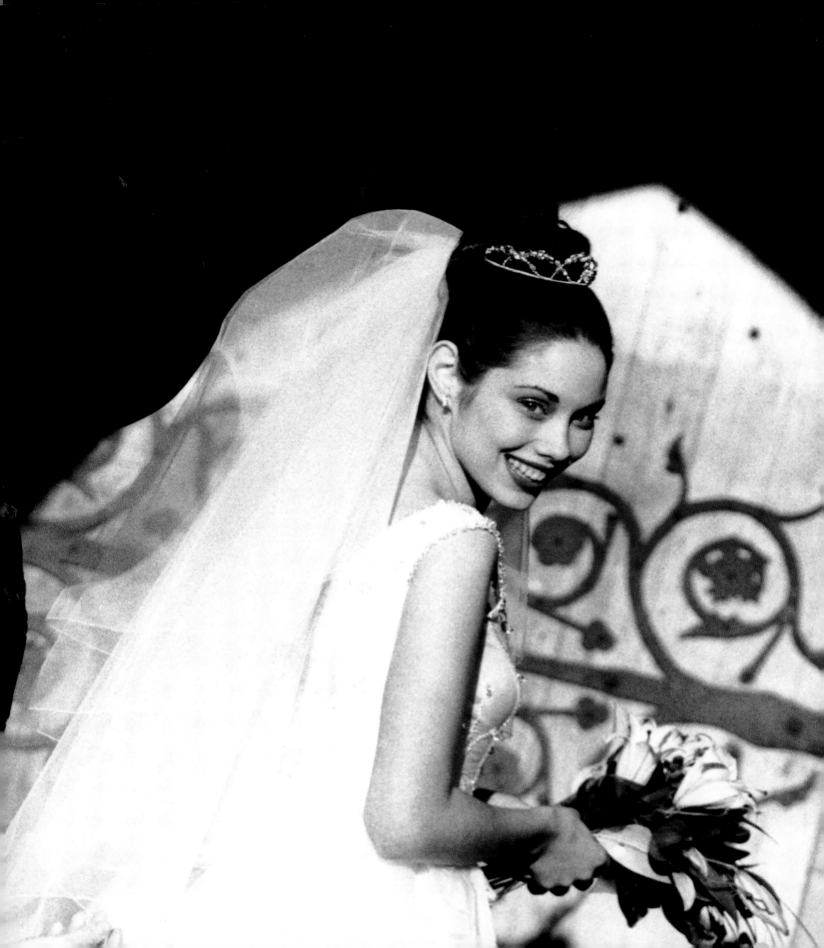

Using tone and contrast

The light in the doorway is directly on the bride and the door behind her, which has led to a stunning mixture of tone and contrast. Because the light is so low, the porch roof of the church has cast its shadow across the whole of the top area of the picture, which has led to the creation of an interesting and unusual frame around the bride.

Use your light meter

The light again was very low here, which has created strong modelling on the faces. Metering directly from this area of the picture has ensured that the couple's features are correctly rendered, while the shadows in the background have been darkened down still further, making the contrast within the picture all the more striking. Taking pictures under these kinds of conditions is very risky, because as the bride and groom move around the churchyard the light may change dramatically from one area to the next, and so constant meter readings are essential to ensure success.

Although I rarely photograph people in bright sunlight, occasionally it can look amazing if the photographs are taken later in the day when the sun is very low, and is throwing deep and exaggerated shadows across everything. The extraordinary quality of light you experience at this time can make the pictures really glow.

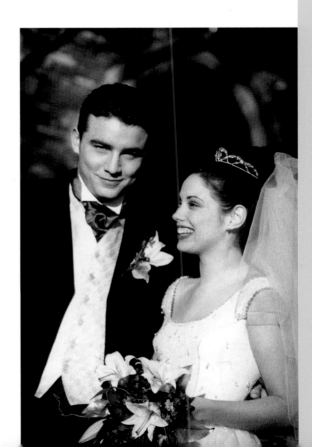

Using a leafy tree
Every bride wants their wedding day to be bright and sunny, but often these are not the best conditions under which to achieve flattering photographs. Harsh shadows may end up being thrown across the face, while the bride might find herself squinting against the light if it's particularly bright.
The simple process of placing the subject in the shadow of a large leafy tree makes it possible to soften the light that falls on the face, therefore creating a far more pleasant picture, whilst the sunlight that's still being thrown around the subject serves to enhance the picture.

Utilising a stone arch
I used a slightly different effect for the groom, standing him underneath the stone arch of the church gateway so that he fell under its shadow. This served to even out the light, and gave me a result that was a vast improvement on what could have been achieved by simply standing him in the direct sunlight. The impression of the lovely sunny day that characterised this wedding is still preserved, however, through the light that's falling on the background, and the shadows that are being thrown there. The shape of the arch, meanwhile, makes a strong frame for the subject.

Capture any opportunity
At first sight it appeared that this little bridesmaid would have to be photographed in direct sunlight, but then I realised that she would be shaded for a moment by the chauffeur as she stepped from the car. That was all I needed, and you can see if you look closely at her shoe how small the area of shadow that I had to work within really was. An instant later and the bridesmaid would probably have been squinting in the sun.

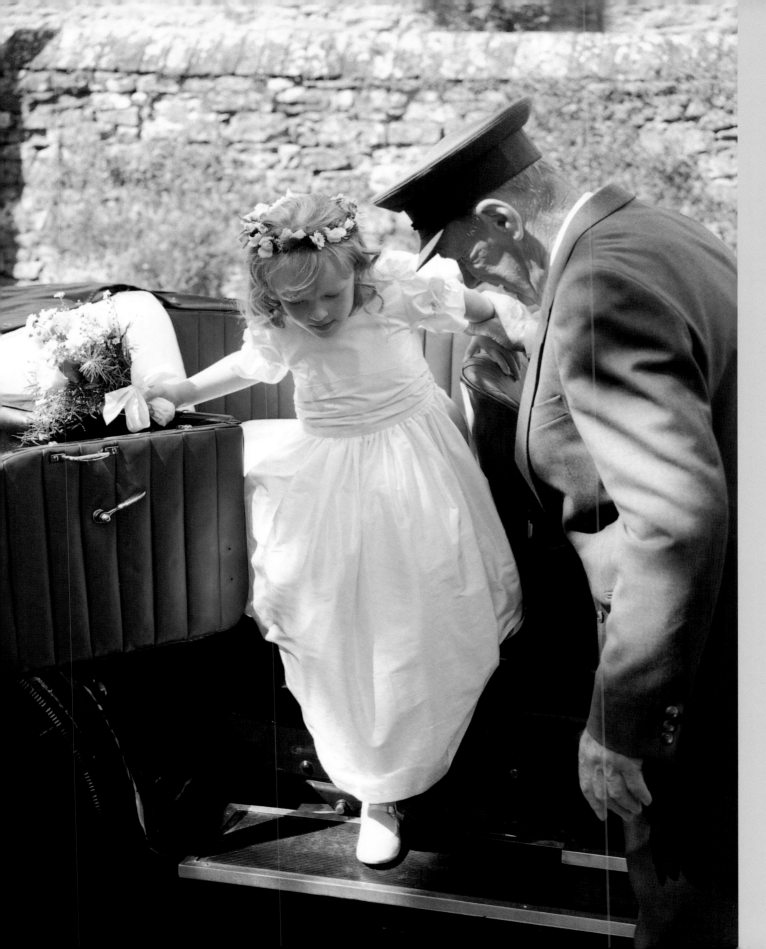

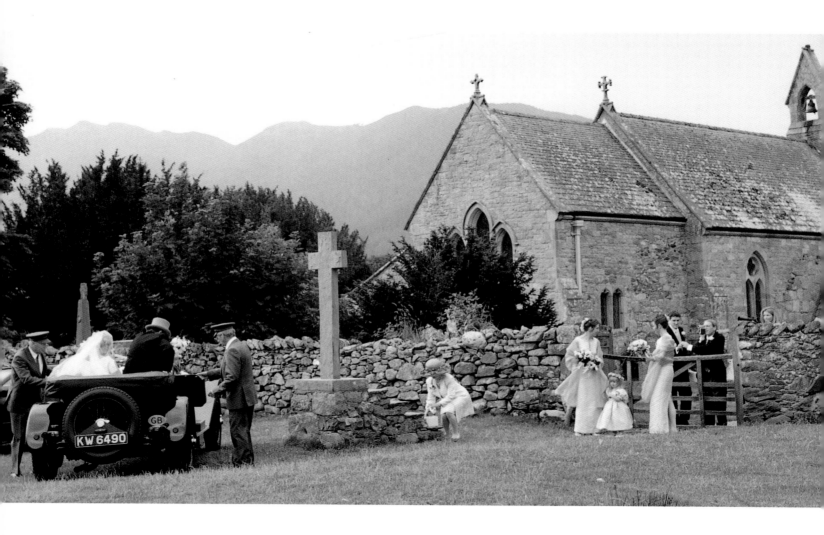

Soft and even light

Most people think a bright sunny day is wonderful for photographs. However, my job is much easier if the weather is dull, because I can take pictures wherever I want without searching for trees to shade the sun. A cloudy, overcast day provides very soft and even light, which is particularly flattering when photographing people. The harsher contrast that will be created by strong direct light can produce dark shadows around faces and eyes, while the exposure difference between the brightest highlights and the deepest shadows will become very difficult to handle.

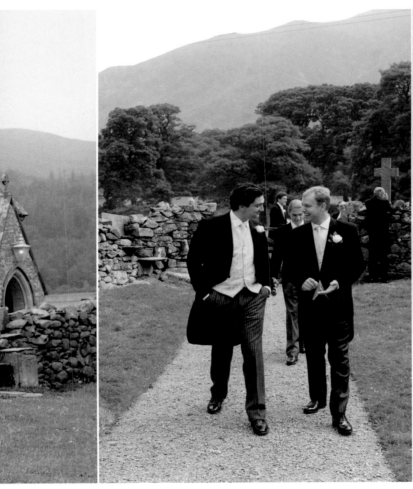

Flexibility

Shooting on a dull day gives me the flexibility of working in a candid style and shooting pictures wherever I want. The cloudy sky creates a soft light that allows the picture to be taken from many different angles, because the light will be very even.

Enhancing the atmosphere

Even a foggy day can provide a striking image. The background detail in this picture has been filtered out by the mist, giving an unusual and ethereal feel, whilst enhancing the subjects in the foreground.

Making rain work for you

Every bride hopes for a sunny day, but unfortunately it can sometimes rain. On most wet days pictures can be captured in between showers but occasionally the weather can be so bad that it seems impossible.

Pouring rain should be seen as a challenge, not a nightmare. It is possible to take some fantastic pictures in the rain because people are totally natural, and shooting in the rain will result in unique and spontaneous images, provided you work quickly and efficiently.

The bride and groom still have to walk to the car, and this gives the photographer ample opportunities for capturing the atmosphere as they walk down the path. There is no reason why they cannot stand under umbrellas chatting to people. They will be so happy, they won't notice the rain!

I will be completely soaked, but that is a small price to pay to make sure the couple get the pictures they want.

It is important, however, that my assistant keeps my camera covered with an umbrella as much as possible to avoid the equipment getting too wet. Breakdowns on the day caused by rain are the stuff that nightmares are made of.

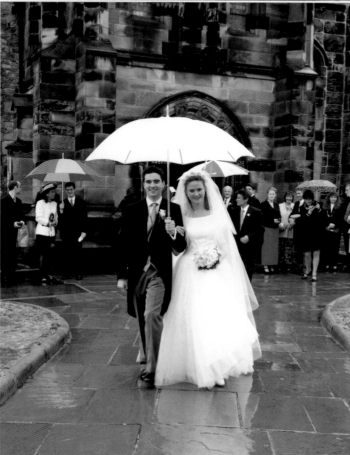

Tip:

Take your own white umbrella with you because it will be invaluable on occasions such as this. Don't be afraid to politely exchange your umbrella for any brightly coloured umbrella the bride and groom may be using, because they will thank you for it later. A white umbrella enhances the pictures by reflecting light back in to the faces, rather than shading them as a dark umbrella would do. Make sure the umbrella does not have logos on it, as these may also spoil your pictures later.

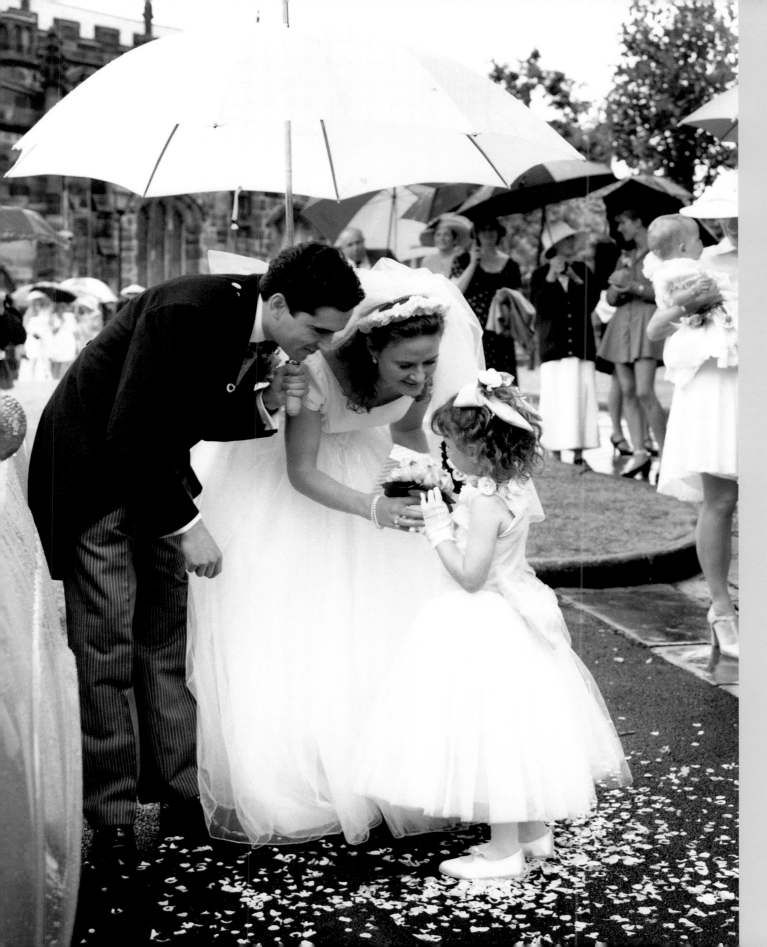

Find some natural cover

Group shots can be especially challenging when the weather is poor. Everyone will have made a special effort to look their best for the day and if the rain is falling they will be doing everything they can to stay dry, and will not be happy about being made to stand outside for photographs.

Because natural light is much more flattering than using flash indoors, I will always try to take the pictures outside if possible. Many receptions have a large covered entrance and this is where I would choose to do the group shots. I usually take several small groups rather than one large one in order to keep all the guests out of the rain.

For this picture, my assistant ferried members of the family out as and when they were needed. With the help of umbrellas held out of the frame, to prevent rain sweeping into their faces, I was able to produce results which were much more flattering than they would have been had they been shot inside.

As always the photographer got soaked standing outside, but at least the groups looked good!

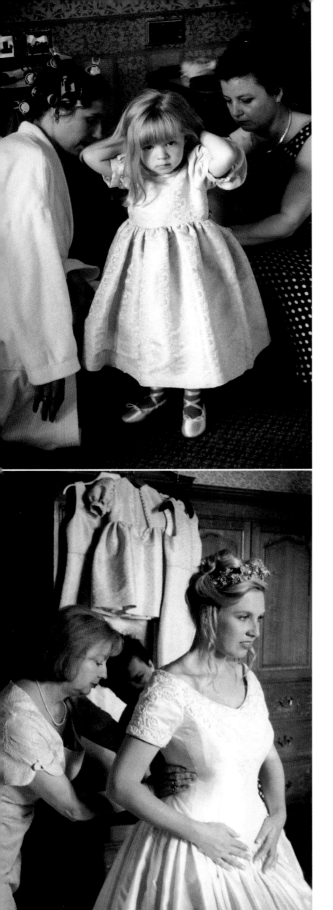

Hand-held 35mm

I find natural light much more flattering for photographs, and therefore hardly ever use flash at weddings.

These pictures are all shot by hand-holding my 35mm Canon EOS 5, with a 35–70mm zoom lens, which enables me to take both wide and close shots within moments of each other.

Occasionally, if the bride's bedroom is very dark, I will use the small pop-up flash on the camera, because it is very unobtrusive.

If I have a choice, I will ask the bride to get dressed facing the window, allowing the light to fall on her naturally. The light will be much more flattering if the bride is standing several feet away from the window, rather than close to it.

Fast film

I always use Fujifilm Neopan 1600 black and white film to give me the extra exposure I need to work in the available light in the bride's home. This film also has the added advantage of grain which gives the pictures texture and adds to the contemporary feel.

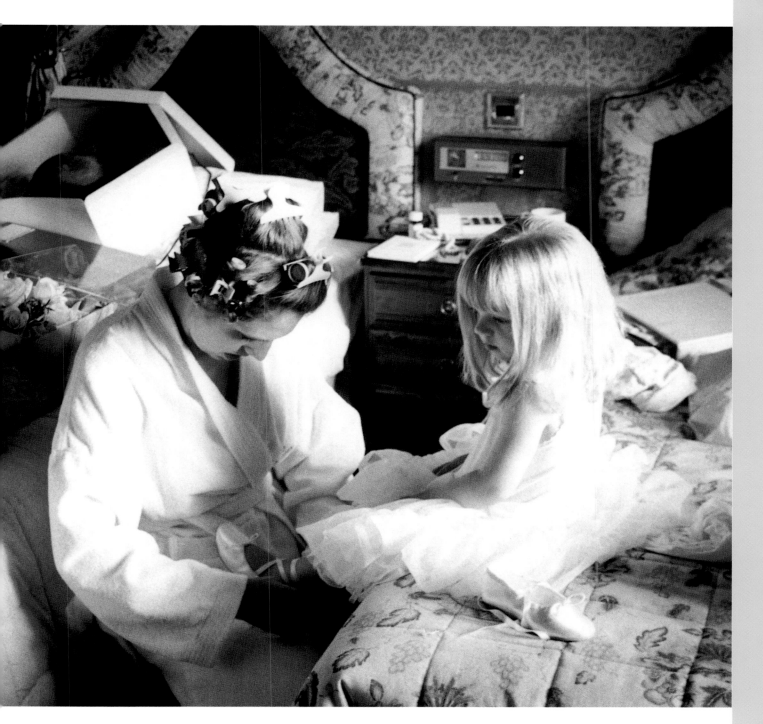

Conventional processing

The above shot has been taken on conventionally processed negative film (Fujifilm NHG 800) and establishes the scene down by the water's edge.

Cross processing

By taking another picture on transparency film (Fujifilm Provia 400) and cross processing it in C41 chemistry more conventionally used for negative films, the image can be given a strikingly different look as the colours are enhanced dramatically.

Cross processing will make strong colours more vivid while washing out the whiter areas of the picture and the results can be highly effective when seen among the overall mix of wedding pictures that you produce.

You will still need, however, to shoot some conventional colour pictures as well, because most brides want to see the detail in their dresses, which cross processing cannot provide.

It is essential to practice this technique before you introduce it on a wedding shoot, because these images can be difficult to print when taken under certain lighting conditions.

Tip:

I find that cross processing for wedding pictures is most effective either in very strong even light, or very soft light. On very dull or wet days, it can give very unflattering results if the lighting is patchy or shadowy. It is essential in this case to use a reflector to even the light out, and this is unfortunately often impractical on a wedding day when you do not want to be encumbered by equipment.

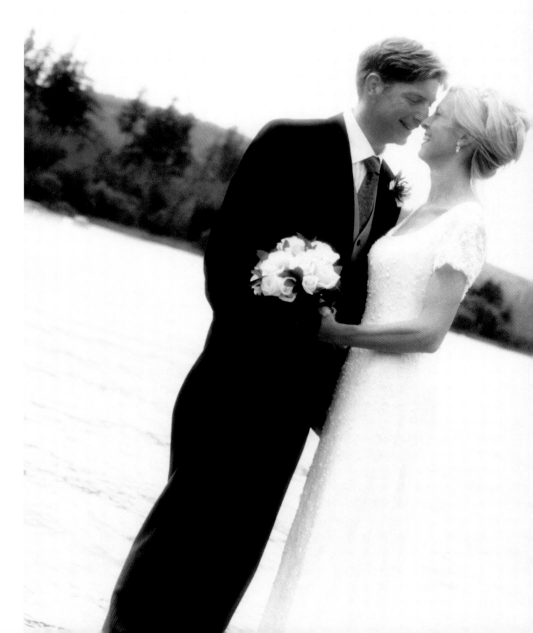

Many of today's clients want to look like the pictures they see in magazines, and the vivid colours and unusual angles that appeal to them can be reproduced by tilting the camera and cross processing the film.

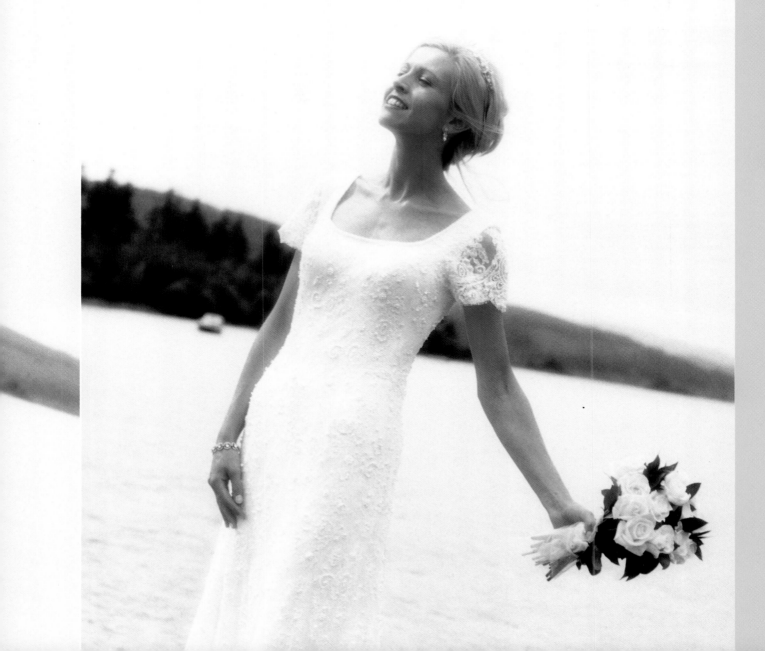

Conventional

The above image has been shot on a Hasselblad medium-format camera with soft-focus filter (Hasselblad softar 1), and Fujifilm Neopan 400 film. This created a moody romantic picture for the couple who requested pictures shot on their family farm. The picture deliberately includes the meadows in the background which have so much sentimental value.

Contemporary

By simultaneously using my 35mm Canon EOS 5 with 70–300mm zoom lens, I can take completely different pictures of the couple without actually moving them. This means I can work much more efficiently and produce a variety of different results.

I use Fujifilm Neopan 1600 film, as the grain gives the pictures a more interesting feel, and allows me to hand-hold the camera at low shutter speeds without camera shake resulting. Using the zoom lens at f5.6 throws the background completely out of focus creating interesting shapes and enhancing the couple themselves, resulting in a much more contemporary image.

Black and white pictures are in huge demand these days from couples who are looking for a contemporary feel in their pictures. Modern films are ultra fast allowing for the camera to be hand-held, which creates a much more spontaneous feel.

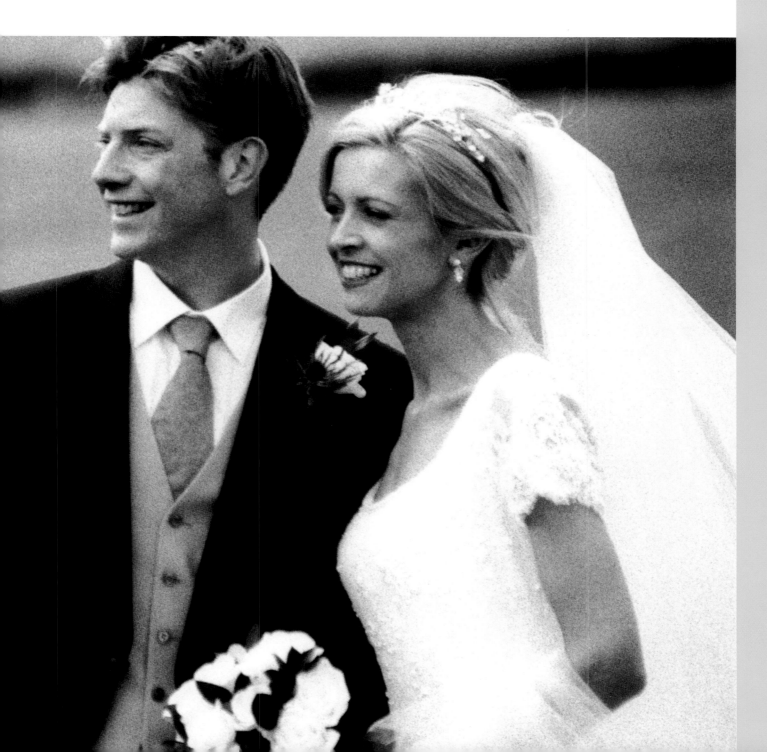

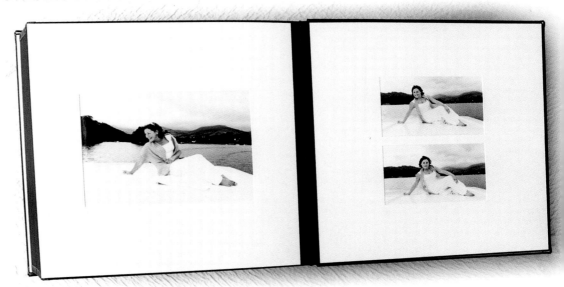

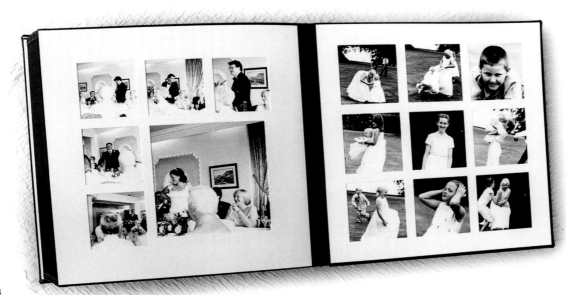

The wedding album is the record of the big day that will be treasured for years to come, and producing a balanced selection of pictures to fill its pages is one of the great skills of wedding photography.

It's likely that many of the pictures that you took on the day were produced with the ultimate aim of running them together as a series, but at the proof stage it's worth looking for others that also work well together, perhaps as smaller images that can be used to complement one larger main picture. Sort everything into chronological order so that your pictures start to tell the story of the day in a logical way, and you've then got the basis for your wedding album.

What you're looking to achieve is variety and a good cross-section of candid-style pictures of the essential characters of the day plus as many guests as possible. You'll have covered all the important stages of the wedding, such as the bride preparing at home, the arrival at the church of bride and groom, the service itself and the group shots afterwards, and you'll need to use a selection of pictures from all of these, perhaps mixing black and white and colour where appropriate, or toning black and white pictures for extra effect. Alongside these pictures, however, there will be a need for general shots, informal pictures of guests mingling and talking. These images will say so much about the day and everyone's enjoyment of it, and they are a vital part of your coverage.

Don't forget to also include pictures of the details, such as close-ups of the flowers, the cover of the service sheet or the back of the bride's dress. These are images that will work beautifully when used in the album alongside the more mainstream pictures, and they will help the atmosphere and flavour of the day to be more completely captured.

Cropping
When you're producing your wedding album don't be afraid to crop images quite dramatically if necessary, if by doing so you can create something that is tighter and stronger. Have a couple of L-shaped cards handy for the moment when your proofs arrive. Used in combination they can be held over a print to show very quickly how any other crop that you might choose to use would actually look and it can be quite staggering how much a picture can be affected by even just a small adjustment. Try to crop into formats that are consistent, however, so that they don't fight one another on the pages of the album. A page of square prints can look highly effective, while one that features a mixture of sizes and shapes is in danger of looking messy.

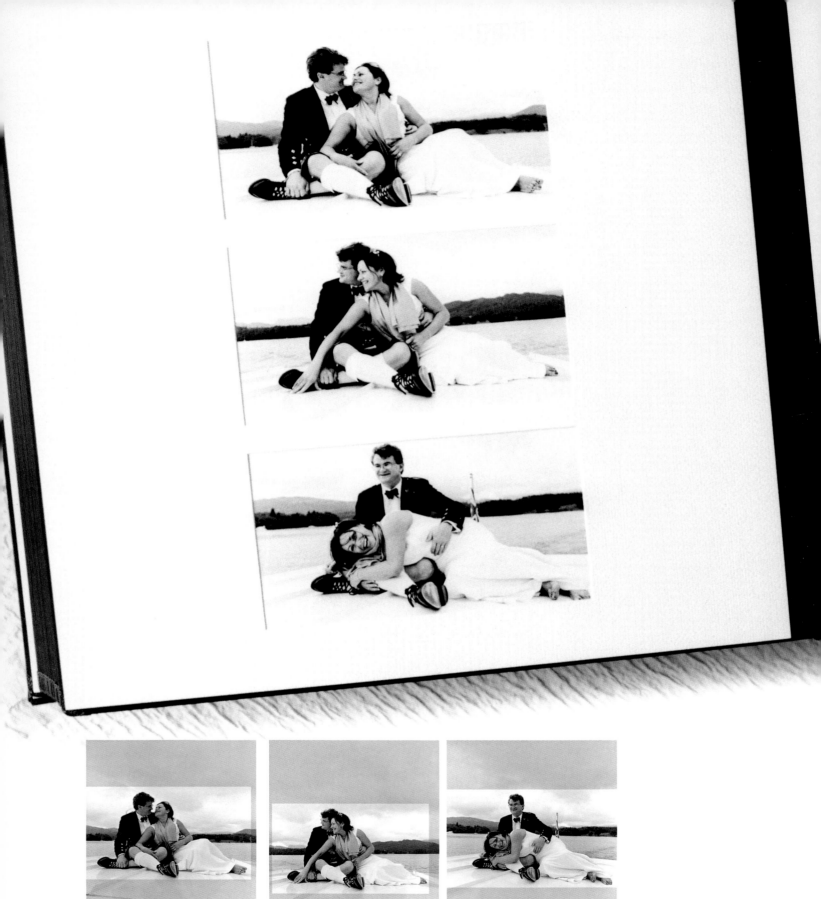

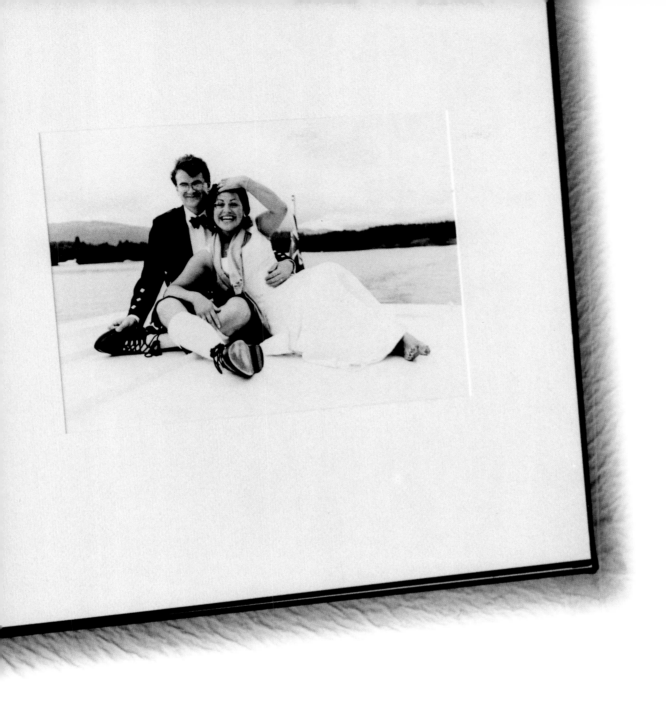

Using a sequence

A single image can work well in an album, but often a sequence can be far stronger. These are pictures that are planned to the extent that you are shooting with the idea in mind of using several together, so you'll need to get your subjects relaxed and to shoot plenty of film. Encourage plenty of movement so that there's a good variety of expressions to choose from, and if you can get the couple laughing while you're taking your pictures then so much the better!

121

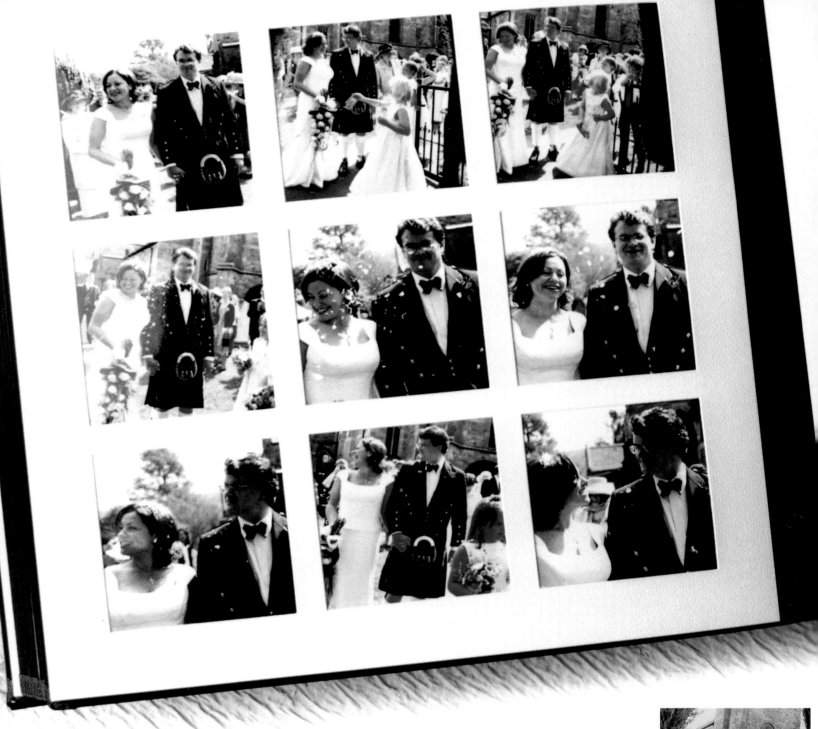

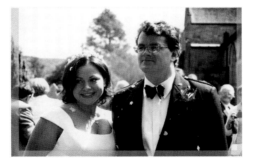

Create impact
Use of a strong image across a full page of the album will contrast dramatically against a page that's made up of smaller images.

With a cohesive feel
When you're planning to use a series of themed pictures across a page, it's essential to give them a uniform look so that they work successfully together. Cropping to a square format can be an effective way of grouping pictures, and it will help to give them a more cohesive feel. Wedding album manufacturers, having realised that the demand for contemporary style is growing rapidly, are now producing overlays that allow photographers more freedom and flexibility in terms of the layouts that they can achieve.

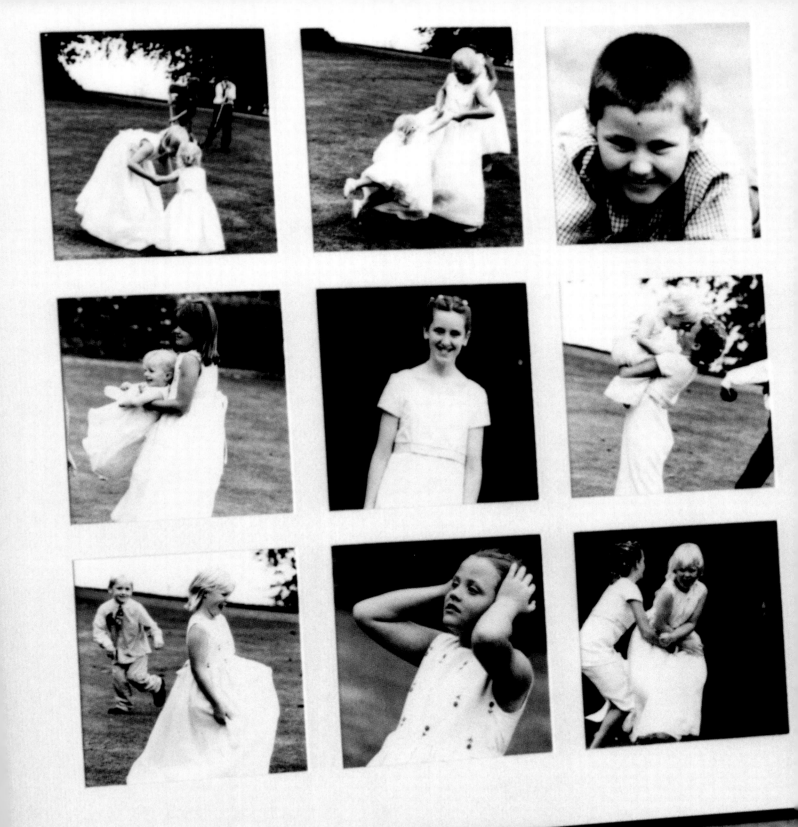

Using a strong format

Applying a square format to a series of candid pictures of children playing at a wedding created the basis for a montage that eventually appeared in the newlyweds' album.

With candid shots

Candid pictures look wonderful in an album and I often set up situations that are designed to give me images that I know will subsequently work well together. On this occasion there was an open area close to the reception that attracted the children, and I encouraged them to come over and play together. Once children get involved in games, the last thing they're going to worry about is being photographed, and I knew that the results would be happy and relaxed.

I shot with my Canon EOS 5 and 35–70mm zoom, which gave me the flexibility to move around my subjects and to work in a candid style. Later I laid out all the pictures, made a selection of those that I felt were working well together, and cropped them down from a rectangular format to one that was square because I felt that this gave them greater continuity. The rigid pattern that they formed across a page was full of impact, and together the pictures represented a side of a wedding that is often overlooked by photographers.

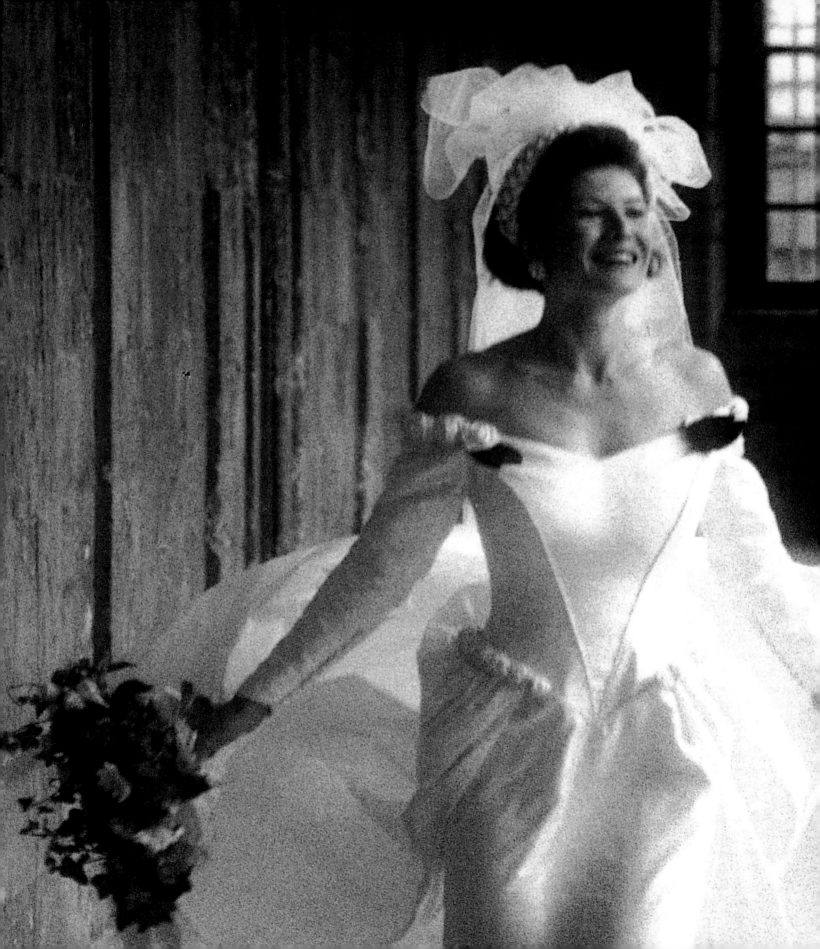

You can promote your services in all the best places but the best form of advertising is still the personal recommendation, which will only come from those who have found your services to be highly professional and capable of delivering a high quality product.

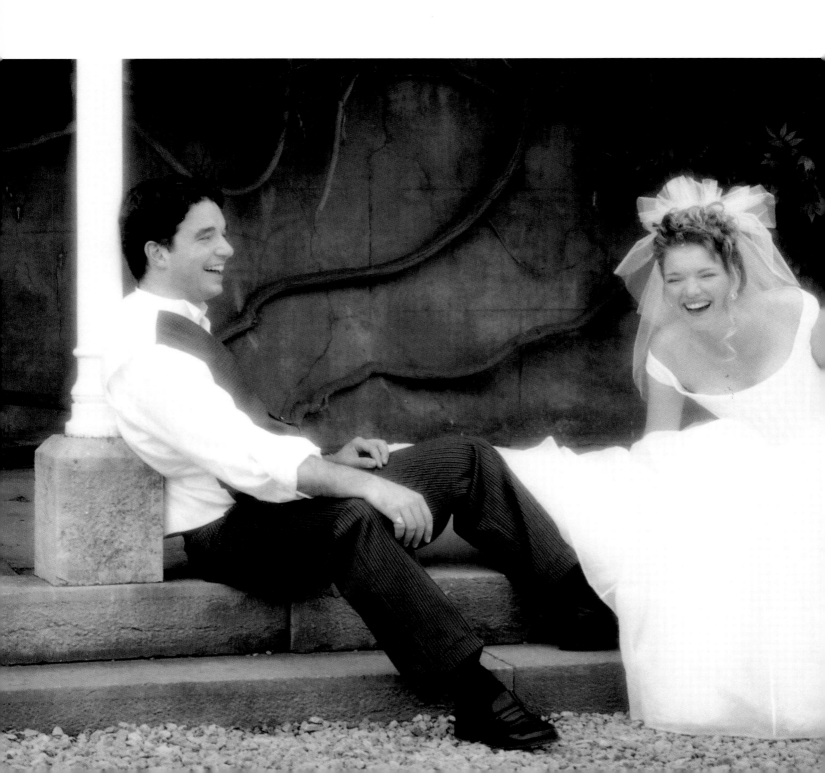

You should be aiming to produce your very best work on the wedding itself, but the importance of following this up with a high standard of after care cannot be over emphasised. Clients who are happy with your service will invariably use you again and recommend you to others.

The best form of marketing and advertising is your reputation and the endorsement of your product by existing clients. The ultimate marketing approach is to give clients a high quality experience, from the time of their initial contact through to the moment when their album of images is delivered and beyond.

These are some of the points that are key elements in the building of a reputation:

Attention to detail – You should offer a high level of service to reflect the marketplace that you are targeting.

Telephone manner – The telephone is often the first point of contact, and a friendly but professional manner should be maintained.

Consultation – A personal consultation is essential to develop a relationship with the client and to allow a mutual understanding to be achieved.

Pre-wedding photo shoot – This heightens the level of trust and reinforces the client's confidence in the photographer.

The wedding day – How you conduct yourself on the wedding day itself will be crucial in terms of client satisfaction, while it will also give you the chance to build your reputation with others who are attending the wedding who may be potential clients of the future.

After care – It is crucial to ensure that the consistency of care continues after the clients have collected their photographs as you are hoping to develop a long-term relationship and to become their personal photographer.

Not only do you want to provide a top quality service, you should be aiming to make every aspect of your business appear highly professional, so that you have the confidence of your clients from the moment that they first contact you. Some of this is certainly down to the look of the studio, and whether it appears bright, modern and welcoming to personal callers, but another crucial element is the strength of the image that you're promoting. It's essential to spend time and money on getting the details right and you should be building a brand personality for your studio that is consistent throughout your stationery, from your letterhead and brochure, though to your web site.

Although it's not a cheap option, you should endeavour to keep your literature as up to date as possible, and to have it well designed, professionally written and printed to a high standard. If you collect any awards these should be highlighted, along with a simple statement about the service that you aim to provide and a selection of pictures that illustrate your style. This is your opportunity to sell yourself to potential clients and if you are aiming to provide a service to the upper end of the market then you'll have to meet high expectations at every level of your business.

A well designed web site is essential as it is an international communication tool which is invaluable to the future expansion of your business. As most photographers now have a web site, your own should reflect your personality and professionalism and contain elements which are unique and individual to you.

Every aspect of your
promotional material should
reflect your brand image,
from your letterhead through
to your brochure and web
site, because many potential
clients will judge your
professional standards on
the information that
they see.

"I started to build my web site when my office was going through a quiet period and I had a little time on my hands...I started with a minimal investment in some cheap software, but ultimately found that this was a false economy because this turned out to be extremely limiting." Glen Smith

www.uq.net.au/~zzglesmi/wedding.html

Glen, who is based in Brisbane, Australia, felt the need to set up a web site because of increasing competition in the wedding photography arena, and it had become clear to him that this was a way to keep up to speed with changing market requirements. His web site is clear and concise starting with a selection of five small images that are designed to convey the full range of wedding styles that he can offer.

It moves on to a resumé of his achievements as a photographer and then to personal endorsements from satisfied clients. There follows a sequence of 11 thumbnail images and afterwards a selection of 14 photographs from a recent wedding. There are links to hot tips on how to choose a wedding photographer, further information on Glen's credentials and a Gallery of a further 14 wedding images.

What was your motivation for setting up this web site?

"I started to build my web site when my office was going through a quiet period and I had a little time on my hands. I was paying for an e-mail site through the University of Queensland, and this provided me initially with five megabytes of disc space, later raised to ten, which could be used to accommodate a site, and it seemed to me that I might as well make use of this opportunity. It was something I was very keen to do and, although I was fairly knowledgeable about computers and had done a lot with Photoshop as well as other digital work, it was much tougher than I had envisaged to get started. I estimate that I spent hundreds of hours getting my site to the stage where I was happy with it: I started with a minimal investment in some cheap software, but ultimately found that this was a false economy because this turned out to be extremely limiting."

What have been the benefits to your business?

"My first wedding commission through the internet came a few months after I set up my web site, and in the first year I had 12 wedding bookings that came directly through this route. I have had one from as far away as New Zealand, but most have been bookings that are more local to me. Because of the vast distances travelled in Australia I give clients my internet address and they can access my work immediately without having to come to see me personally. Younger couples, especially, are happy to do business by this medium because they are more comfortable with computers and it could be that many of the people who are accessing my site are using their office facilities."

How has your web site evolved?

"I now have about 80 images on the site and am still only using eight megabytes of the ten that are currently available. I have put in a huge amount of work since I started out creating the right key words for my site so that people can find me easily and quickly. If I had just the word 'wedding' listed, then I would struggle, because there are so many other listings that are covered by this. I've added other categories such as 'photographer', 'Australia', 'Queensland' and 'Brisbane' to narrow things down a little, and this has helped me to be found more readily. I've found that these keywords are vital if you are to have your site accessed by those you hope will go on to become your clients."

"The fees that I can charge for my work have justified the cost of setting up the site initially: the new site is costing me between £5000 and £8000, but this compares to one-off advertisements in magazines which can cost £2500 a time. A web site is accessible for 24 hours a day as well, and I consider it's very good value." **Gordon McGowan**

www.gordonmcgowan.co.uk

Not only has he received 30 prestigious wedding awards to date, but Scotland-based photographer Gordon McGowan is also the holder of a Golden Web Award for the quality of his web site and since winning this prestigious prize hes started to develop a new and even more state-of-the-art site. "I will have two web sites in operation," says Gordon. "One will be a static site and the other a moving one." With both sites running Gordon hopes to cover every angle of the marketplace, appealing to the more traditional couple as well as the trendy young things that are only impressed by fast moving wizardry.

Even the static site features the odd touch of trickery, such as the software that allows the user to create the impression of waves by moving the cursor over Gordon McGowans name, and there are descriptive words that gently evolve onto each page of the site. There are over 60 images on Gordon's Gallery section collected under a series of different sub-headings: 'Creative', 'Digital', 'Contemporary' and 'Fun'. There's also a profile page, awards details, advice and contact information. Even straightforward information pages such as these have a life of their own, appearing to split apart and reform over a period of time.

What was your motivation for setting up this web site?
Gordon was quick to see the potential that a web site would offer his business, and was on-line some time before many of his rivals. "I like to embrace new technology and this is the way forward. This is a visual age and the site has incorporated my ideas and helped me to publicise my business to a wide audience."

What have been the benefits to your business?
The web site has helped to give Gordon an international profile and he feels that it has aided him to win bookings from couples travelling to Scotland for their weddings from such diverse countries as Australia, America, Hong Kong and Gambia. "I am the most expensive photographer in Scotland but this is not a problem for couples travelling from overseas as they expect to pay a lot more for their wedding photography, particularly those coming from Australia. The fees that I can charge for my work have justified the cost of setting up the site initially: the new site is costing me between £5000 and £8000, but this compares to one-off advertisements in magazines which can cost £2500 a time. A web site is accessible for 24 hours a day as well, and I consider it's very good value."

How has your web site evolved?
Gordon keeps up to speed on web site development, and is considered by many to be a market leader. It is his own ideas that are interpreted by a webmaster and developed into the site. "This new site will be very much in your face," says Gordon, "and it will feature contemporary graphics as well as dance music. We suggest at the opening sequence that you turn your speakers up really loud to get the full benefit!"

"**I set out to make our site as interactive and as comprehensive as possible and now I feel that people are drawn to our site because they are physically comfortable sitting in their own homes and are free to look at our work in their own time.**" **Joseph Raymens**

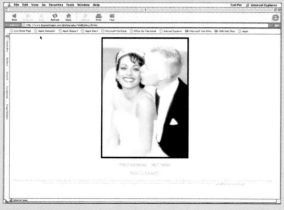

www.beyondimages.com

Set up by Joseph Raymens, the owner of the Beyond Images Photographic company in the US state of Oregon, the www.beyondimages.com web site has turned out to be a huge success and is currently gaining over 1,700 hits in a typical quarter. Although not dealing exclusively in wedding photography the site has an extensive interactive wedding section and the company feels it is very important to its business to be able to offer a complete wedding package.

To achieve this criterion a diary of available dates is featured, along with images of wedding albums, a comprehensive list of names and addresses of related businesses, a wedding chat zone where users can ask for help and information and details of an on-line bridal magazine. There is also a feature of the moment where brides can sometimes view bridesmaid dresses and accessories and at other times hand-blown glass cake tops. If Beyond Images hasn't extracted enough information at this point then there is a very comprehensive order form.

With all this and 12 static photographs available to view maintaining this site is labour intensive since it requires continuous development and updating. However, even with the level of detail regarding a couple's wedding that Beyond Images requests, the company does not feel that the web site is a substitute for a personal meeting with its client.

What was your motivation for setting up this web site?
"It was set up for advertisement purposes. We were aware that many photographers had a basic web site at the time and I knew that I wanted to offer prospective clients more than they had. I set out to make our site as interactive and as comprehensive as possible and now I feel that people are drawn to our site because they are physically comfortable sitting in their own homes and are free to look at our work in their own time. They can contact us via the web site when they are ready to make a booking."

What have been the benefits to your business?
"We have now really started to be found by people. It has taken a lot of work but now we are getting bookings continuously through our web site. It is a great way to make initial contact with people."

How has your web site evolved?
"It started off very much as a learning process. I knew a little about the setting up side when I first sat down, but I very much learnt as I went along. It started off looking a little uncomfortable but it has gradually evolved and now I feel that it has quite a professional look."

"Noticeably my office is now a much quieter place. I now get more e-mails than telephone calls and it cuts down on a lot of time. Clients can browse the site, look at my photographs and then telephone if they like what they see. About 20% of my clients have booked without us even having met." **Stephen Swain**

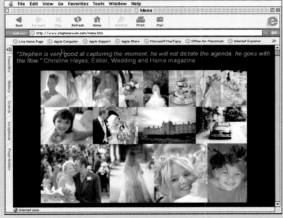

www.stephenswain.com

Stephen Swain is one of a new breed of Britain-based wedding photographers who have moved away from what Stephen describes as a "tacky, stiff and staunch" style and on to a more contemporary approach of reportage or documentary style wedding portraiture. He is a high achieving photographer averaging 60 weddings a year and this is reflected in the Gallery section of his web site where there are over 60 diverse photographs available to view. The site opens with a hugely engaging photograph of a bride enjoying a moment of hilarity with her three bridesmaids and a summary of Stephen's credentials. There follows a personal endorsement from the Editor of the influential British magazine Wedding and Homes and 16 thumbnail pictures.

Lastly is the menu where viewers can find out more about Stephen, look at his Gallery, discover how to contact him and then click on links to connected service recommendations.

What was your motivation for setting up this web site?
"I view it very much as the ideal medium for a photographer and was also aware that many other photographers were promoting themselves via the internet. I did not view it as an option, it was just something which had to be done."

What have been the benefits to your business?
"Noticeably my office is now a much quieter place. I now get more e-mails than telephone calls and it cuts down on a lot of time. Clients can browse the site, look at my photographs and then telephone if they like what they see. About 20% of my clients have booked without us even having met. I firmly believe that had I not gone on-line when I did I would now have less work than I do. It has also been incredibly useful for clients who have partners working abroad, because they can look at the site simultaneously and agree that they like the photographs while sitting in different parts of the world."

How has your web site evolved?
"I set it up myself with the help of my wife Marija who had the technical expertise. I wanted to keep it simple so that the links are very obvious. We only update the site about once every six months as the one-off nature of the business means that it does not go out of date quickly. I advertise the services of other people that I have worked with and whom I feel offer a good service and in many cases this works as a good reciprocal arrangement. One tip I do have is to put the web site in your own name as this makes it easier for people to remember you."

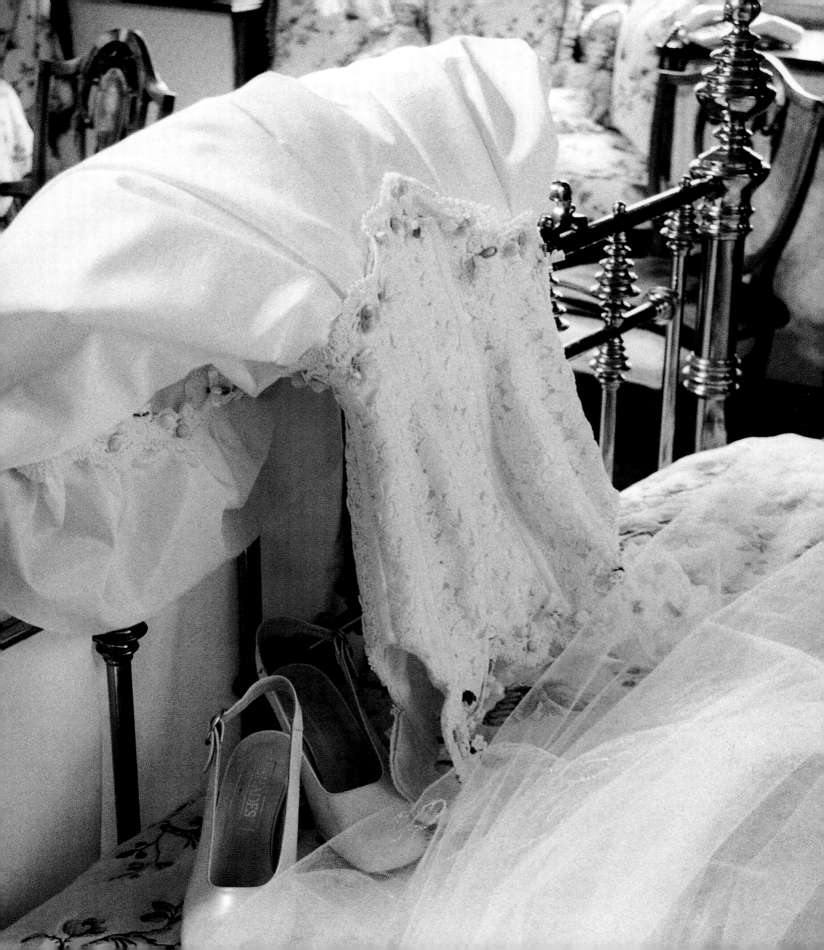

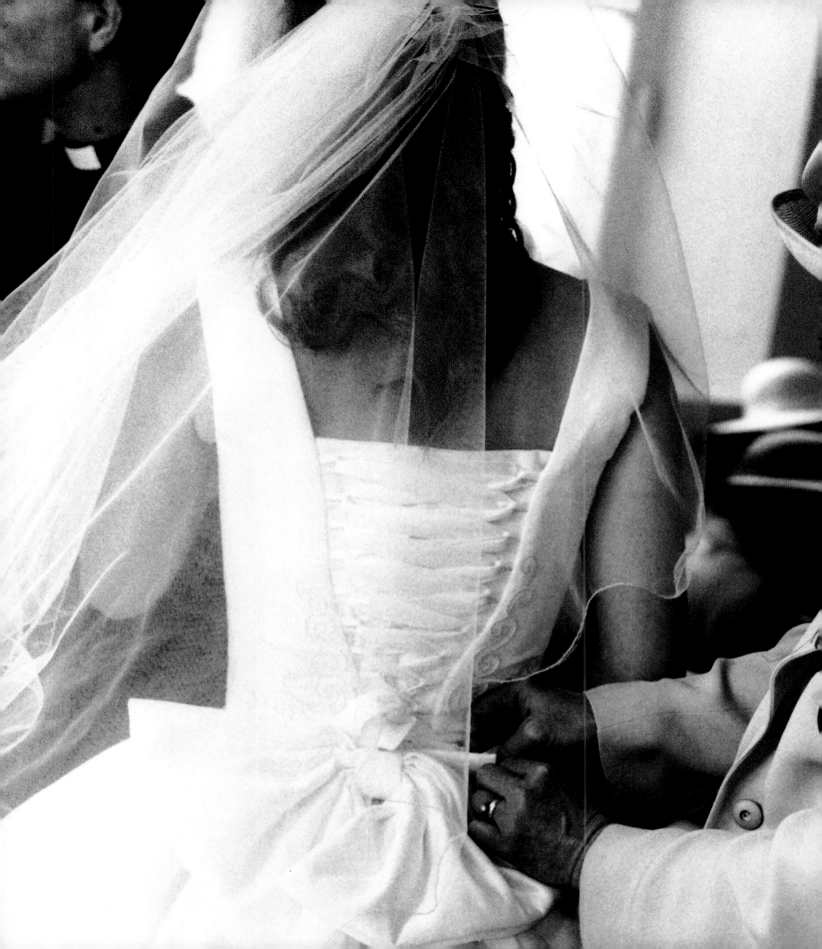

Wedding Breakfast Menu

Melon Cocktail

❤

Tomato & Orange Soup
with a hint of
Fresh Rosemary

❤

Herb Crust Sirloin of Galloway Beef
On Yorkshire Pudding with
Roasting Gravy

or

Supreme of Chicken
served with a Red Wine Sauce

All served with a selection
Chef's vegetables

❤

Strawberries and Clean
served with Vanilla Ice Cream

❤

Freshly Brewed Coffee
and Mints

A RED, RED ROSE

O, my love's like a red, red rose,
That's newly sprung in June.
O, my love's like the melodie,
That's sweetly play'd in tune.

Liz

Steve

Thank you for sharing our 'special day'
Liz & Steve

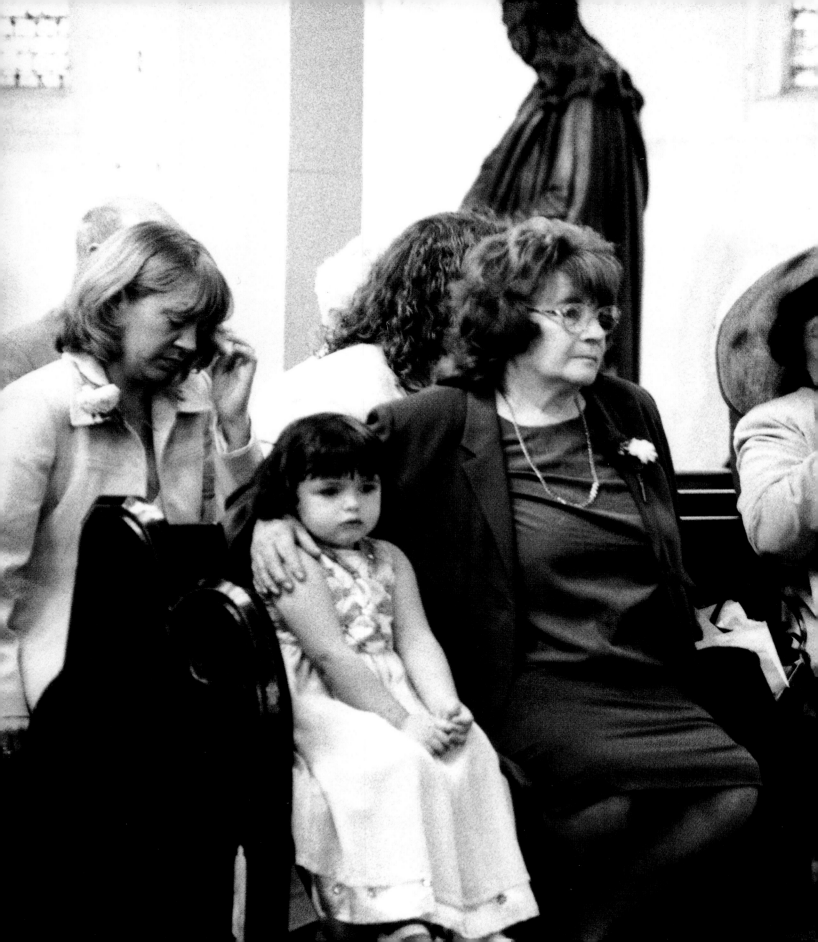

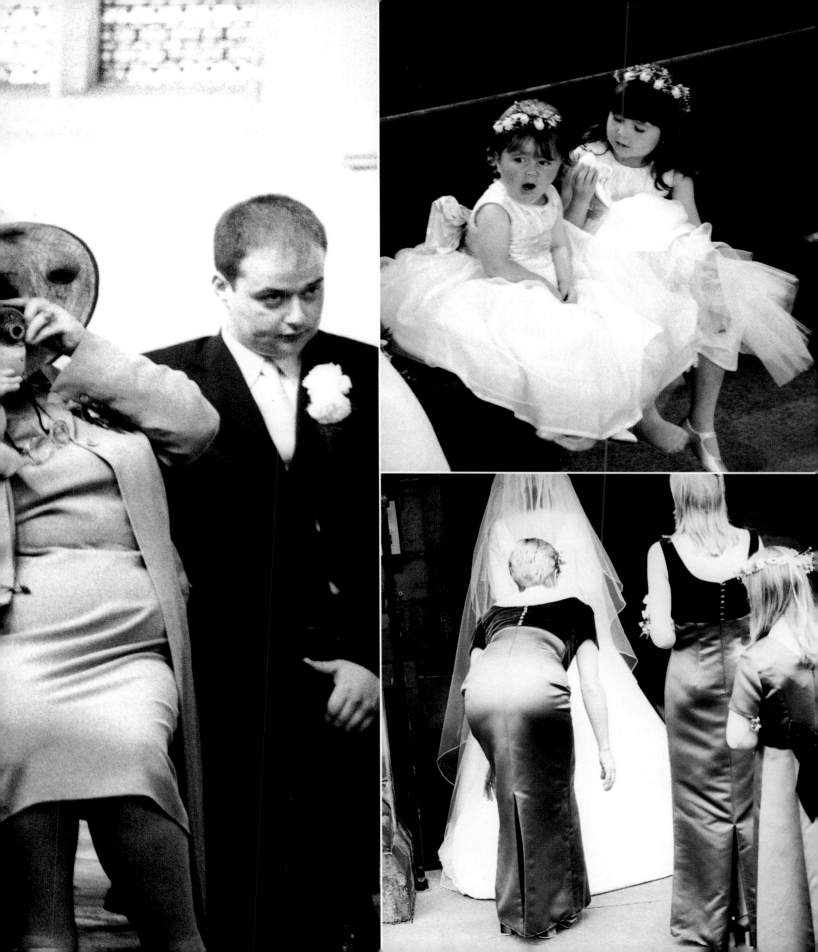

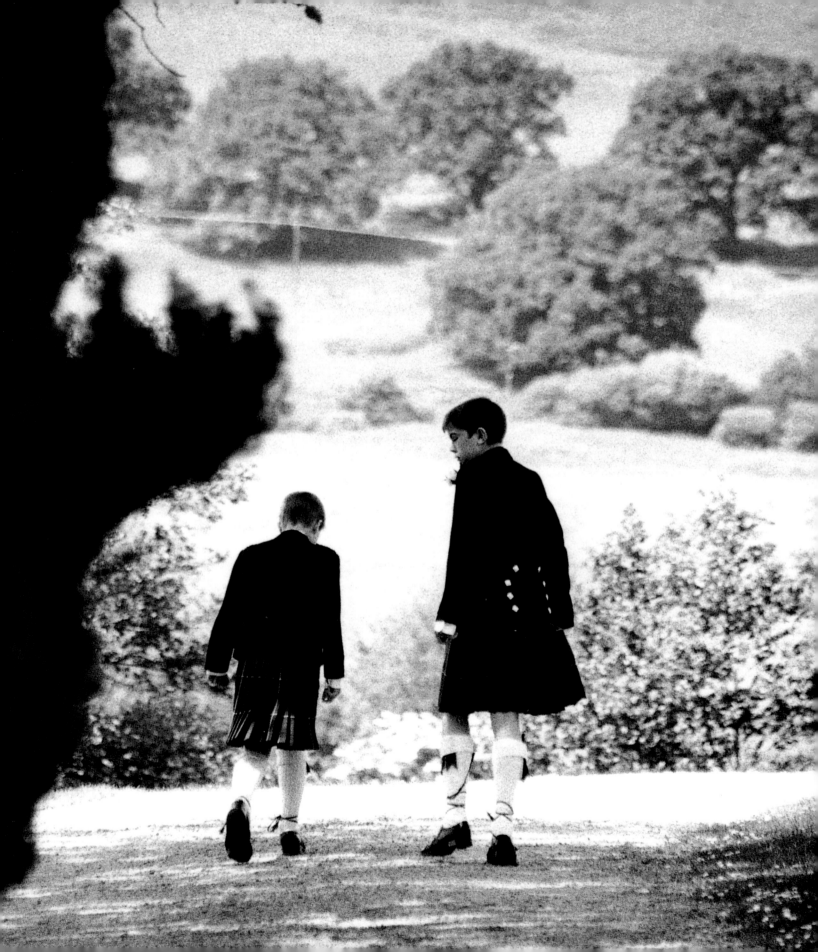

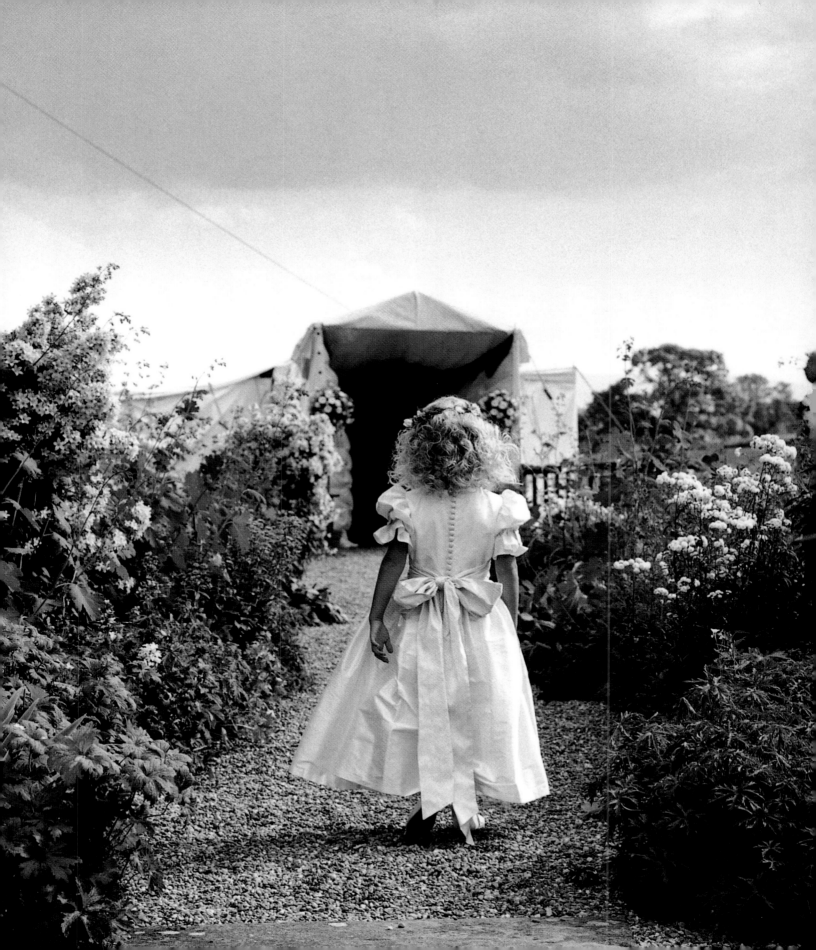

acknowledgements

With thanks to all my wonderful clients who were happy to let me use their images, Manchester Colour Labs, UK, for all their excellent printing and Queensberry Albums, New Zealand, for designing the perfect wedding albums!

Many special thanks to Jane, Kate, David, Polly, Lucinda, Sandi, Catherine, Fiona, Lisa and Joanna for all their support and assistance.